The Campus History Series

NEW ENGLAND
SCHOOL OF LAW

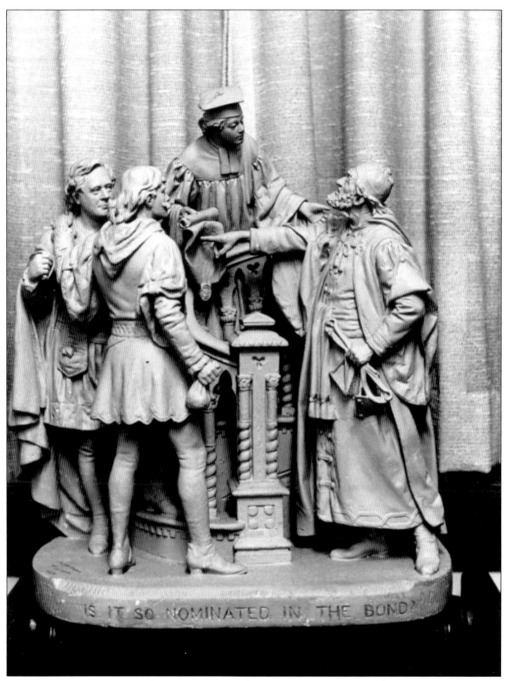

IS IT SO NOMINATED IN THE BOND?

This sculpture group has been a symbol of New England School of Law for many years. It represents Portia's famous speech in Shakespeare's *The Merchant of Venice*. It is a reminder of the school's history as Portia Law School, founded to educate women in 1908 when very few could obtain a legal education. It also symbolizes the law school's struggle, like that of its early graduates, to win a status commensurate with its quality.

On the cover: Please see page 15. (Courtesy of New England School of Law Archives.)

The Campus History Series

NEW ENGLAND SCHOOL OF LAW

PHILIP K. HAMILTON

ARCADIA
PUBLISHING

Published by Arcadia Publishing
Charleston SC, Chicago IL, Portsmouth NH, San Francisco CA

Printed in the United States of America

Library of Congress Catalog Card Number: 2008920522

For all general information contact Arcadia Publishing at:
Telephone 843-853-2070
Fax 843-853-0044
E-mail sales@arcadiapublishing.com
For customer service and orders:
Toll-Free 1-888-313-2665

Visit us on the Internet at www.arcadiapublishing.com

CONTENTS

ACKNOWLEDGMENTS

The sources for this history are many and varied: scrapbooks, photographs, letters, notes, transcripts of interviews, minutes of meetings, law school records, and the memories of individuals, among others. To my knowledge, there have been only three attempts to describe the history of the school in a narrative form. One is a three-page anonymous work that describes the actions of the school's governing board from 1908 to 1968. The second is a pamphlet prepared by Gerard F. Rogers, the school's former director of public relations, for the 75th anniversary in 1983. It emphasizes the personal stories of graduates. The third is a series of two articles published in *Due Process*, the school newspaper, in 1990 and 1991 and written by Paul E. Liles, then a student. It presents information extracted from several sources but especially from the scrapbooks that were kept by the administration until the 1950s. I thank those authors and the New England School of Law Library, which has enabled me to use all of those many sources in putting together this photographic history. I am particularly indebted to Karen Green, the library's archivist, who was unfailingly creative in locating photographs and information. I am also grateful to Prof. Anne Acton, the director of the law library, and Cornelia Godfrey, the director of student services, who met with me regularly to check my progress and offer help. And I thank Sandy Goldsmith, who coordinated the project and did some editing. I am grateful as well to my colleague Prof. Ronald Chester, whose oral history interviews, conducted with Portia Law School graduates in the early 1980s, were an invaluable contribution to my understanding of student life at the school in the 1920s and 1930s. His 1985 book, *Unequal Access: Women Lawyers in a Changing America*, from Bergin and Garvey Publishers, is the product of that research. I would also like to acknowledge the contributions of Martin Foster, Diana Wheeler, Frank Scioli, Judi Greenberg, Sue Calamare, David Berti, Rudelle Fenty, Lexi Macmillan, Gloria Vasquez, Paula Lamonica, and Jacqui Pilgrim. Finally, I thank Dean John F. O'Brien for making this project possible.

INTRODUCTION

In the early 20th century, the law—like many professions—was mostly limited to men, generally those from families with means. In 1906, Arthur Winfield MacLean, a recent graduate of Boston University Law School, joined his classmate Gleason Archer in giving classes to the sons of working men and immigrants. In 1908, MacLean was asked by two young women to help prepare them to take the Massachusetts bar examination. As Archer's program of instruction was open only to men, MacLean agreed to teach these two women independently.

By the following year, MacLean's classes included 10 women, and the number had grown to 30 by 1914 when Archer's law school moved out of their jointly rented space, leaving MacLean's operation on its own. MacLean, carrying most of the teaching responsibilities himself and relying on loans from his own funds to pay the bills, continued to attract students. In 1918, with 91 women now enrolled, MacLean incorporated his enterprise as Portia School of Law.

That same year, the law school sought authorization from the legislature to award the LL.B. (bachelor of laws) degree to women and to change its name to Portia Law School. The resulting bill was signed by Gov. Calvin Coolidge on June 27, 1919, making Portia the only law school in America established exclusively for women.

In 1921, with an enrollment of more than 200, Portia Law School purchased a building at 45 Mount Vernon Street on Beacon Hill. The school continued to grow and to prosper, and MacLean was indefatigable in his efforts to promote the school and the legal education of women. He wrote newspaper articles and lectured on the subject. He encouraged his students to "bring a friend" to class.

When the Massachusetts Supreme Judicial Court announced that, as of 1938, two years of college study would be required to sit for the bar examination, MacLean established a liberal arts college so women (and men) who would ordinarily not be able to attend college could earn that credential through night study. Largely as a result of the Depression, enrollment had begun to decline. In response, MacLean asked the legislature to allow Portia to award the bachelor of laws degree to men, a request that was granted in 1938.

Throughout its early history, Portia was a part-time institution with a faculty that —except for MacLean—was made up of practicing lawyers who taught only a course or two. The students were also part-time, taking four years to obtain the bachelor of laws degree. This part-time character kept costs low and enabled working men and women to improve their status by earning a law degree. Portia was one of many part-time law schools in the period between World Wars I and II, but it was the only one dedicated to

training women. MacLean energetically pursued that mission and when he died in 1943, his vision and dynamism could not be replaced and were sorely missed.

Although Portia had been able to accept male applicants since 1938, it was not until the postwar years that men outnumbered women in the student body. Enrollments had fallen precipitously during World War II, and the school turned to the GI Bill for financial salvation. Because those eligible for that federal program were mostly men, Portia quickly became a predominantly male institution.

During the 1950s and 1960s, the law school continued to provide a low-cost legal education. Many of the graduates of those years went on to distinguished careers. But the days of part-time law schools were past, and Portia found itself increasingly outside the mainstream of legal education and less attractive to applicants. By the mid-1960s it was clear that Portia could survive only if it adopted national standards and obtained accreditation from the American Bar Association's (ABA) Section on Legal Education and Admissions to the Bar. That would require the establishment of higher admission standards, a full-time faculty, a larger library collection, a new core curriculum, and improvements to the physical plant.

Starting in the early 1960s, but gathering force when Judge James R. Lawton joined the board of trustees in 1966, the law school embarked on a major transformation. The 1919 charter was amended, giving alumni a more prominent role in governance. The liberal arts college was closed in order to provide more space and resources for the law program, and the school's name was changed to New England School of Law. In 1969, the school received provisional ABA approval, and full approval was granted in 1973.

The result of national accreditation was an immediate increase in applications, and the new tuition revenue enabled the school to make further improvements. In 1972, the Mount Vernon Street buildings were sold, and the school moved to larger quarters in Boston's Back Bay. In 1980, the school moved again to its present location in Boston's theater district.

Enrollments, faculty, and library all continued to grow. The 1980s saw the development of a rich and varied clinical program as well as the hiring of new faculty through a national process instead of through the local Boston marketplace. In the 1990s, under the leadership of Dean John F. O'Brien, published faculty scholarship increased, and the school established three academic centers. Steps were taken to internationalize the curriculum, and the school became a founding member of the Consortium for Innovative Legal Education, leading to the creation of summer study-abroad programs. A program was also established to support community among racial minorities, leading to increased enrollment of minority students. In 1998, New England School of Law was admitted to the Association of American Law Schools, an acknowledgment of its attainment of the highest standards in legal education.

Now an institution of more than 1,000 students, New England School of Law has a student body that hails from throughout the United States as well as from other parts of the world. It is known for its excellent clinical programs, its international program, its academic centers, and for its dedication to superior teaching. In the spirit of its history of enablement, it offers several part-time programs in addition to its full-time day program. More than half of the law school's students are women, and it continues to strive to provide an environment that is comfortable for them and for others who have suffered discrimination, past or present.

Although it is now a large law school, students often remark on how small and intimate it seems, from the accessibility of the faculty to the sense of community that is shared among students, faculty, and staff. Perhaps that is because the school forged its traditions when it was a small school and has been able to preserve them through its growth. It is the goal of this book to present, through photographs, the development of those traditions and thus to communicate an appreciation of the unique character of New England School of Law.

One

THE MACLEAN ERA, A WOMEN'S LAW SCHOOL 1908–1943

When Portia Law School was founded, legal education was very different than it is today. There were a few elite law schools that required a college degree for admission. But the vast majority geared their entrance standards to the admission requirements of the local bar, and very few states at that time required even a high school diploma. The case method and Socratic dialogue had not yet caught on as methods of instruction, and law teachers everywhere were predominantly practicing lawyers who taught part-time. In the universities, law was usually a full-time course of study, although many also had part-time divisions. In addition, there were a growing number of exclusively part-time schools, attracting working people who lacked the resources to attend a university law school. Those part-time schools saw themselves as providing democratic access to the legal profession.

In 1908, when Arthur Winfield MacLean took on his first women students, social mores and family demands prevented many middle-class women from finishing high school, and only the wealthier went to college. That was especially true in immigrant families, from which the bulk of Portia's students were to come. MacLean was not a feminist, but he was convinced that women had the minds and temperament to excel in law study and law practice. In 1908, only two years of high school were required of applicants to the Massachusetts bar, but soon the bar examiners were pushing for a high school diploma or its equivalent. MacLean responded by adding a high school equivalency program in the summer. Later, when the bar requirement was increased to two years of college study, MacLean founded a college to enable his law students to meet that standard.

In addition to providing an education, MacLean took steps to ensure that Portia Law School enjoyed a respectable reputation in the Boston community. He made the newspapers aware of the school's high bar pass rate and the success of its graduates in practice. He sent press releases and notices of the school's commencement ceremonies, alumni functions, and clubs and sororities. In the 1920s and 1930s, Portia Law School was a mainstream Boston institution.

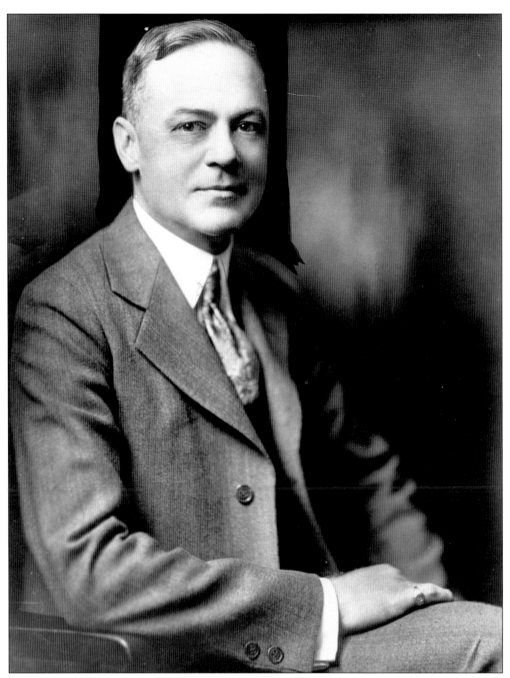

Arthur Winfield MacLean was born in Lowell in 1880. He received a bachelor of arts degree in 1903 and a law degree in 1906, both from Boston University. He was from a middle-class family, and he financed his education by running the university bookstore, an operation that he owned by the time he graduated from law school. In 1906, MacLean joined his classmate and law partner, Gleason Archer, in tutoring men who aspired to pass the Massachusetts bar examination. Archer's classes for men ultimately became Suffolk Law School. (Courtesy of the Boston Public Library.)

In December 1908, MacLean took on two women as his own students and decided that his future would lie in training women in the law. MacLean's and Gleason Archer's classes were located initially in Archer's Roxbury apartment and then in their Tremont Street law office. In 1909, Archer and MacLean rented space for their classes in the Tremont temple, pictured here. (Courtesy of the Bostonian Society/Old State House: Postcard Collection, c. 1898–1945.)

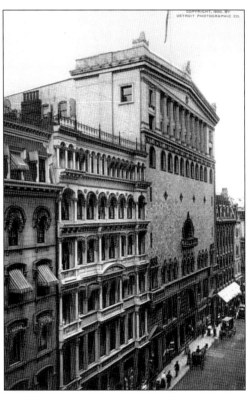

In 1909, 10 women enrolled in MacLean's program. A. Chesley York, another young attorney, joined MacLean as the second faculty member of the women's school. York was the city solicitor of Medford from 1918 to 1921, an assistant attorney general from 1921 to 1927, and an assistant United States attorney from 1927 to 1934. York was associated with the school for 43 years, as a teacher, a trustee, and finally as dean.

11

In 1910, Arthur Winfield MacLean married Bertha L. Robinson. It is said that she suggested the name Portia School of Law for MacLean's growing educational enterprise, a reference to the advocate-heroine of Shakespeare's *The Merchant of Venice.* The school's original incorporation in 1918 was under that name. A year later, the school was reincorporated as Portia Law School by special legislative charter that also authorized it to award the bachelor of laws degree to women. (Courtesy of Jean MacLean Currie.)

Bertha was far more than the dean's wife. Having studied at Wellesley College for three years, she graduated from Portia Law School with honors in 1920, passed the bar, and joined the law school faculty, where she taught courses in criminal law, wills, agency, partnership, domestic relations, and negotiable instruments. In 1924, she was appointed assistant dean and comptroller, and she served in those positions until her resignation in 1939, several years after she and MacLean were divorced. (Courtesy of Jean MacLean Currie.)

MacLean was an energetic promoter of his law school and of women's ability to study law. He gave lectures, placed announcements and other items in newspapers, and issued "invitations" and "tickets" like these to his first class of each school year. The result was that Portia's enrollments climbed steadily, with 24 women in 1910, 40 in 1915, and 177 in 1920. From 1925 to 1930, enrollment was more than 400 in every year.

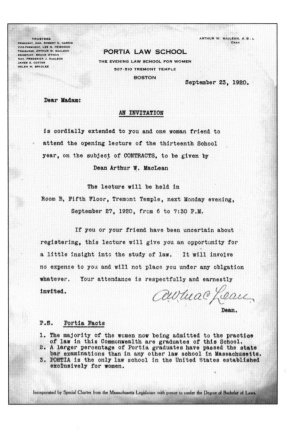

When the law school awarded its first bachelor of laws degrees in June 1920, 21 went to the class of 1920 and 18 went to earlier graduates. This is a photograph of Louise M. Davis, president of the class of 1925. She went on to hold offices in the Portia Law School Alumni Association, a very active civic and social group throughout the 1920s and 1930s. She also taught at the law school in the 1920s.

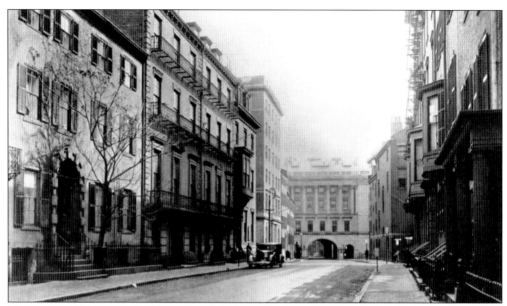

In 1920, Portia Law School began offering a part-time day program in addition to the evening classes. In 1921, with an enrollment of more than 200, the school purchased this building at 45 Mount Vernon Street on Beacon Hill. The building had been owned by Suffolk Law School, which had left the Tremont temple in 1914. Arthur Winfield MacLean remained a member of the Suffolk faculty until 1922, when he resigned to devote his time completely to Portia.

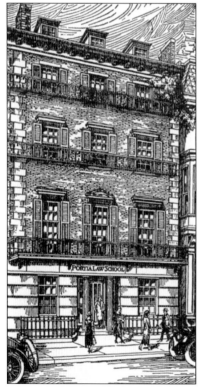

The school was always a not-for-profit educational enterprise. The 1919 act of incorporation specified that the school's income be directed to paying the expenses of its maintenance. MacLean described it in the catalog as "an educational institution of eleemosynary or charitable character," and noted that "all of its income must be wholly expended for the benefit of its students." The increasing enrollments of the 1920s enabled him to improve the school's programs.

MacLean supported school social events. For several years, the school sponsored "Portia Law School Night" at the Boston Pops Orchestra concerts in Symphony Hall. The school's participation in such events helped to develop an image of solid respectability and engagement in the city's civic and cultural life, an image sought both by the school and by its students, many of whom were seeking to improve their position in life. Here is a pops program from the 1920s.

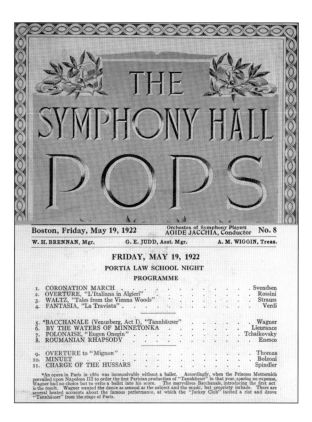

This is part of the class of women who entered in 1924. They are shown enjoying a freshmen-class banquet, probably in the spring of 1925. Eighty-seven of those women were awarded the bachelor of laws degree four years later. In a part-time school, social events like this provided rare opportunities for the day and evening students to get to know each other.

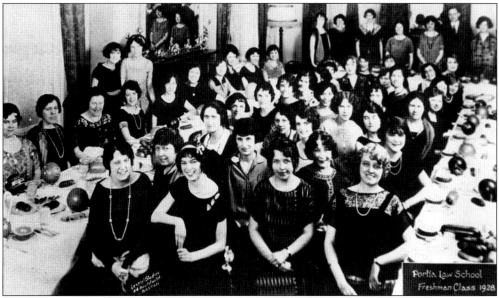

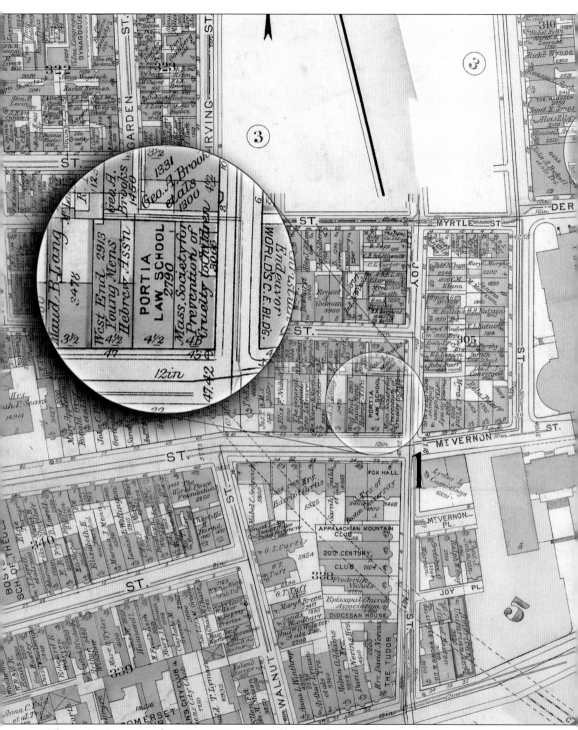

These 1928 maps of Boston's Beacon Hill area show Portia Law School (1) on Mount Vernon Street. Note its proximity to the Tremont temple (2) and to Ford Hall (3), where early graduations were held. Note also that Suffolk Law School (4) and Boston University Law School (5) were in the same area. The Suffolk County courthouses (6) housed a

16

library that students used when working on projects that required research beyond the small Portia Law School library. Boston College Law School, founded in 1929, was also located on Beacon Hill and eventually so was the Northeastern University School of Law, founded in 1898 as the YMCA Law School. (Courtesy of Community Heritage Maps.)

As in many law schools at the time, instruction at Portia Law School was by lecture followed with questions from the students. Students were also responsible for working out written problems between classes. Professors provided students with their typed lecture notes, which students then annotated, as shown here. Although the students read some cases, the case method of instruction was not yet generally used in law schools, especially in the part-time schools.

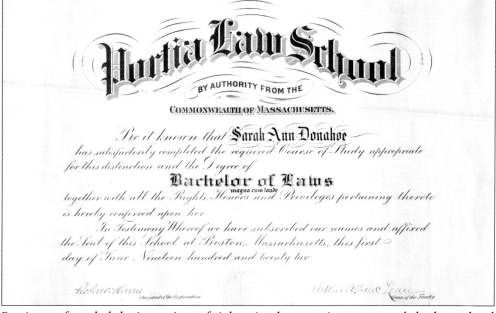

Portia was founded during a time of tightening bar requirements, and the law school responded by increasing its own admission standards. Since 1914, a high school diploma had been a graduation requirement, and in 1921, Arthur Winfield MacLean opened a summer school, allowing women to complete a high school equivalency program. In 1931, the law school began requiring a high school diploma for admission.

In 1926, the legislature gave Portia the power to grant the LL.M. (master of laws) degree to both women and men. The first five of these degrees were awarded in 1927, all to women. It was not until 1930 that two men received the master of laws degree and became the first male recipients of any Portia degree. This is a photograph of John William Sliwa, who received the master of laws degree in 1931. (Courtesy of Andrew Tabak.)

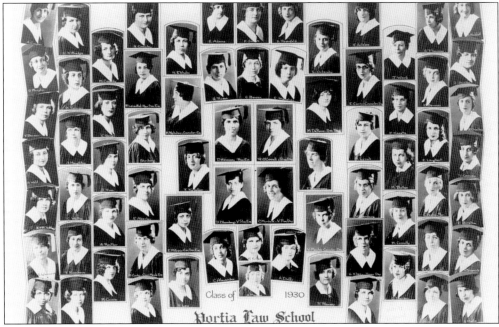

In the 1930s Portia graduates continued to do well on the Massachusetts bar exam, as they had since the school was founded. Of 28 women passing the winter 1930 exam, 18 were from Portia. Of 16 women passing the winter 1932 exam, nine were from Portia. On the summer 1934 exam, 15 of the 20 successful women were from Portia.

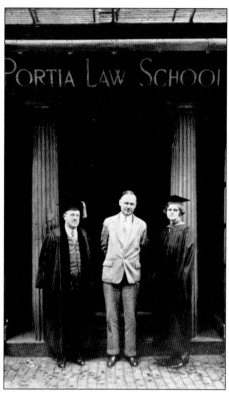

Bessie N. Page was a beloved and long-serving member of the Portia Law School faculty, having joined it in 1924, the year of her graduation from the law school. A brilliant teacher, she also ran a bar review course that was popular with both men and women graduates of the various Boston law schools. Around Portia, Page's concern for students was legendary. She is pictured here before the impressive 45 Mount Vernon Street entrance with Arthur Winfield MacLean (center) and faculty member A. Chesley York.

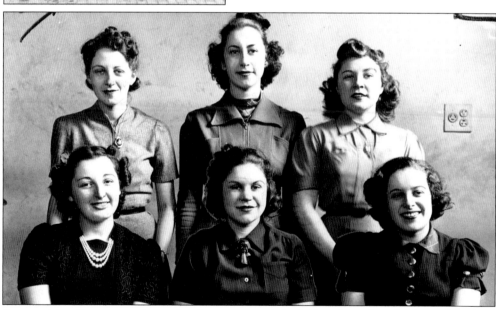

For most Portia women, law school represented their first foray into higher education. College-type social organizations abounded, including sororities, legal fraternities, and ethnic or religious clubs. The first student club was the Menorah Society, which had a chapter at Portia in 1919. It was followed by a Newman Club and eventually an Italian Club, all reflecting the immigrant origins of many of the students. This is a photograph of the Menorah Society dance committee in 1939. (Courtesy of the Boston Public Library.)

Both the law school and the college, founded in 1934 in connection with Portia, supported thriving acting groups in the 1930s and 1940s. In the upper photograph are two law students in an amateur show presented at the Boston YMCA in 1939. At right are students from the college in a production of *Death Takes a Holiday*, staged at the Peabody Playhouse in 1940. (Courtesy of the Boston Public Library.)

Portia Law School graduates did well on the bar examination, but most did not take it because they did not intend to practice law. Many went to law school to enhance their employment prospects as legal secretaries, title examiners, or in other work with a legal content. Others had families and wanted an interesting education—and work—that allowed a flexible schedule. During the Depression, jobs were scarce, especially in law, where there was much prejudice against women practitioners. Many Portia graduates entered practice in the offices of lawyer husbands or relatives. Pictured at left, Margaret DeRoma (class of 1930) practiced with her brother, another recent law graduate. Pictured below, Minna Kapstein (class of 1936) was married when she entered Portia. Three of her 10 children were born while she was in law school, but she still managed to edit the yearbook and graduate in four years while commuting from Providence.

In recent years, the law school has often recognized a graduate from the Arthur Winfield MacLean era by conferring an honorary degree at graduation. The above photograph is of Jacqueline Guild Lloyd, who was honored at the 1988 commencement. She graduated cum laude in 1933 but was not able to take the bar exam until 1934 because she was not yet 21 when she graduated. She passed on her first try and practiced with her father, who was a lawyer. The photograph below is of Ruth Weiss Coran. She graduated magna cum laude from Portia in 1937 and passed the bar that year. After a brief stint in a general practice firm, she worked for many years for banks doing real estate and probate law. Here she looks over her Portia yearbook. She was honored at the 2003 commencement.

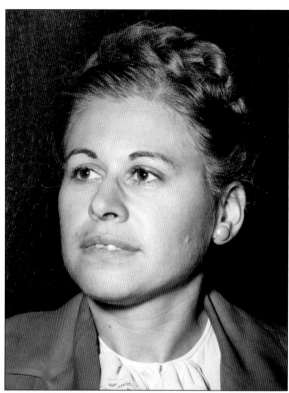

Gladys Shapiro (class of 1936) was able to use family connections to get her first job. Her family owned a liquor store, and she was hired after graduation by a family friend who saw her argue before the licensing board. After several years in a firm, she went out on her own, specializing in licensing cases, representing the Boston Packagemen's Association, and entering Boston politics. The photograph at left is of Shapiro in 1947 during a political campaign. The photograph below is from the 1995 commencement, when she was given an honorary degree. Behind her are trustee Dr. Harold Udell (left) and Chairman James R. Lawton. When she died in 2001, she left the law school a generous bequest. (Courtesy of the Boston Public Library.)

In 1934, the Massachusetts Supreme Judicial Court announced that students beginning law school after 1938 would be required to have competed two years of college in order to take the bar examination. Arthur Winfield MacLean responded in the same year by founding a college, first called Portia Junior College and renamed Portia College of Liberal Arts in 1935. In 1936, it was empowered to confer degrees on both women and men. This is a photograph of the officers of the college's student council for the 1938–1939 school year. (Courtesy of the Boston Public Library.)

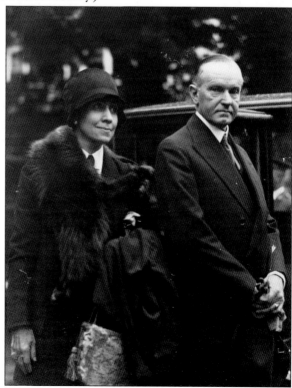

To differentiate the college from the law school, its name was changed in 1940 to Calvin Coolidge College of Liberal Arts, with the permission of Grace Coolidge, the late president's widow. Grace, noted for her friendliness, was an unusually popular first lady. From 1940 to about 1950, the men's law program was called Calvin Coolidge Law School and had its own catalog. After 1950, both men and women received their degrees from Portia Law School. (Courtesy of the Boston Public Library.)

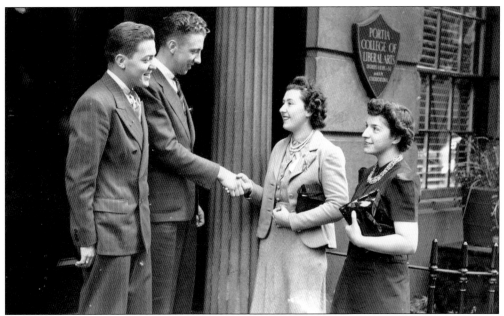

Because of the Depression and the new bar requirement of two years of college, Arthur Winfield MacLean realized that Portia Law School could not maintain enrollments unless it admitted men. It had not yet become common for women to attend college, especially women who did not come from wealthy families. In 1938, only 20 of the 268 students at Portia had completed two years of college. (Courtesy of the Boston Public Library.)

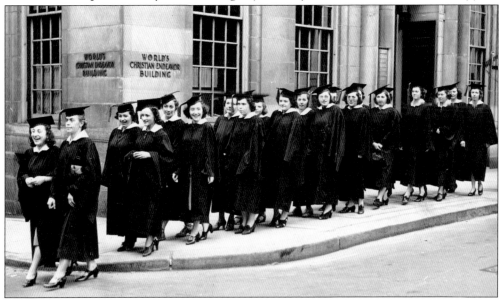

MacLean overcame initial resistance, and in 1938, the legislature and governor approved a bill allowing Portia to grant the bachelor of laws degree to men. This is a photograph of part of the graduating class of 1939. Graduation ceremonies were held in Ford Hall on Beacon Hill. The graduates processed to Ford Hall in full regalia. Thomas J. Haggerty, Portia's first male bachelor of laws degree recipient, was a member of this class. (Courtesy of the Boston Public Library.)

Ford Hall, where Portia's commencement exercises were held for many years, was a landmark on Beacon Hill. The hall was built around 1900 under a grant specifying that it be used for good works. It was run by the Boston Baptist Social Union, which in 1908 started the famous—and ongoing—Ford Hall Forum, the country's oldest free public lecture series. (Courtesy of the Ford Hall Forum.)

PORTIA LAW SCHOOL

Thirteenth Annual
Commencement Exercises

JUNE 4, 1924, AT EIGHT O'CLOCK
FORD HALL
ASHBURTON PLACE, BOSTON

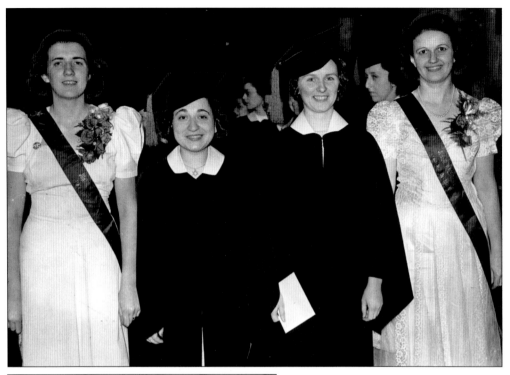

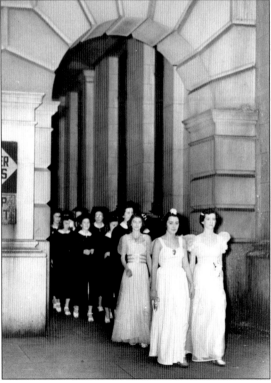

The graduation procession was traditionally led by marshals from the junior class who wore white gowns. In the above photograph are the presidents of the day and evening division of the class of 1939, along with two marshals. In the photograph at left, the marshals lead the 1940 graduates through the state house portico on their way to Ford Hall. (Courtesy of the Boston Public Library.)

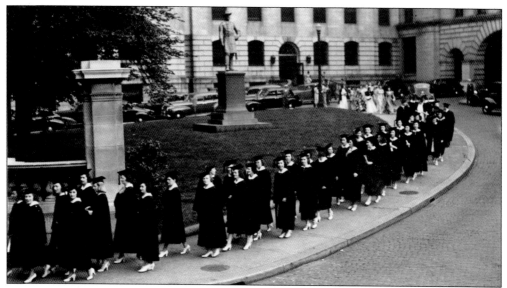

Here are the Portia Law School graduates of 1940 parading to Ford Hall to receive their diplomas. A few male graduates can be seen toward the end of the procession. There were 59 graduates in 1940, but enrollment overall was falling. In the 1939–1940 school year, Portia enrolled 206 students, but in 1940–1941, there were only 133. The Depression and the impending entry into World War II were taking a toll. (Courtesy of the Boston Public Library.)

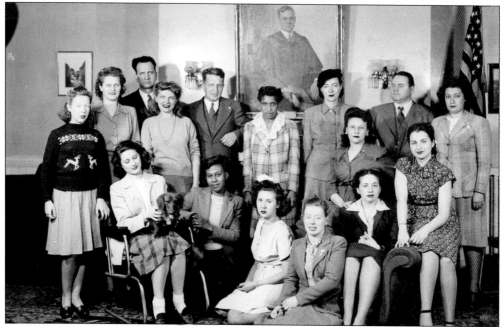

Although the law school had admitted men to its bachelor of laws degree program since 1938, the student body remained predominantly female until after World War II. This is a photograph of the MacLean Club in about 1940. The club was organized in honor of the founder, whose portrait hangs on the wall in the background. The portrait was presented to Arthur Winfield MacLean by students and alumnae in 1926.

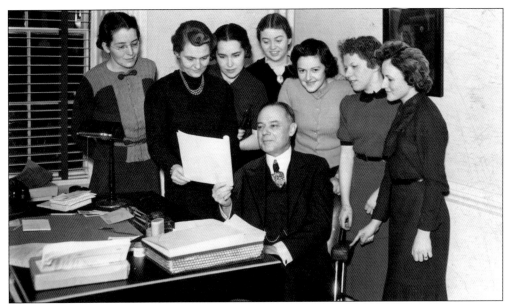

Throughout his life, Arthur Winfield MacLean maintained a keen interest in his students and graduates. He followed their careers, proudly clipped news articles on their accomplishments, and sent letters of encouragement to them. Since he taught nearly every year, he was personally acquainted with hundreds of Portia Law School's graduates. Here he checks student contributions to the community fund in 1938. (Courtesy of the Boston Public Library.)

MacLean made sure that the Boston newspapers had information on events at Portia, and he also kept the law school's profile high through his management of honorary degrees. Here he is seen flanked by Boston mayor Maurice J. Tobin (left) and Massachusetts lieutenant governor Horace T. Cahill before awarding them honorary degrees in the commencement exercises of 1940. (Courtesy of the Boston Public Library.)

In 1933, Portia Law School celebrated its 25th anniversary. Even in that Depression year, 275 students were enrolled. Although enrollments had declined from their high of 433 in 1927, MacLean must have been pleased with the continued strong interest of women in acquiring a legal education. As World War II approached, that interest declined, leading to lower enrollments. (Courtesy of the Boston Public Library.)

Applications to the law school reached a nadir during World War II, when total enrollment fell below 30 students. MacLean made the school's facilities available for civil defense and Red Cross training during the war.

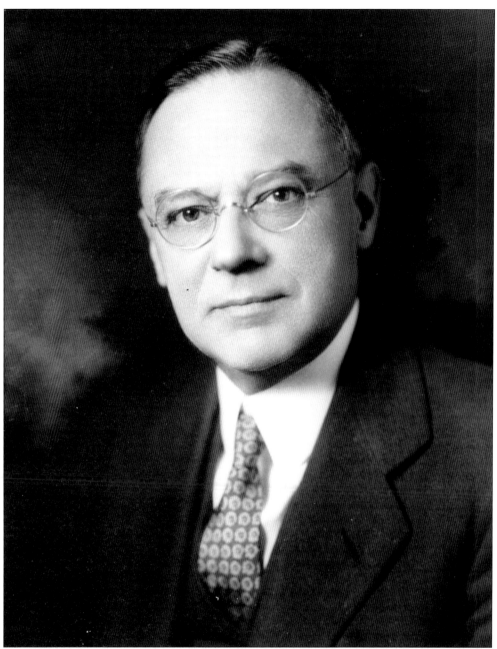

On February 28, 1943, Dean Arthur Winfield MacLean died. He had built a respected institution, had provided thousands of women with an opportunity to improve their status in life, and had enabled many to enter and succeed in a profession that had historically been closed to them. From the law school's founding in 1908 until his death, he had been the animating force that drove the school's accomplishments and kept it in the public eye. (Courtesy of Jean MacLean Curry.)

Two

THE MIDDLE YEARS
1943–1969

MacLean's death in 1943 coincided with a precipitous decline in enrollment caused by World War II. Young women and men were foregoing law study for war-related work or enlistment in the armed forces. Enrollment began to recover in 1945, as a result of the education benefits of the GI Bill. However, nearly all the new applicants were men. Only eight bachelor of laws degrees were awarded in 1948 but seven of them went to women. In contrast, there were 44 graduates in the class of 1949, and 39 were men. The character of the law school had changed forever.

The postwar years also saw significant changes in legal education. Part-time law schools were becoming fewer as the American Bar Association (ABA) used its accrediting power to upgrade admissions standards, foster a national core curriculum, and encourage the development of full-time faculties of professional law teachers. During those years, many legislators sought law degrees at Portia Law School, and many of them went on to distinguished careers in government or on the bench.

However, for most applicants, the characteristics that had attracted students in the past—low tuition, part-time study, instruction by accomplished practitioners instead of full-time professors, a flexible curriculum, and admission standards geared to bar requirements instead of educational attainment—now limited the school's attraction, as law school applicants sought the enhanced prestige of national accreditation. The trustees at first seemed content with a smaller law school and gave most of their attention to the college, which was attracting more students than the law school in the 1950s.

Finally in 1963, the trustees instructed the administration to make the changes necessary to obtain ABA approval. That required significant upgrades to admission standards, the library collection, and the physical plant, as well as the hiring of a full-time faculty. Those difficult changes proceeded slowly at first. In 1966, three new trustees were added, all graduates of the school. One of these was James R. Lawton, who became the school's chairman of the board and led the school for almost four decades. After the addition of the new trustees and under Lawton's leadership, the school sought legislative approval of a change to its charter, increasing the representation of alumni on the school's governing corporation. The necessary upgrades were finally made, and in 1969, the law school was given provisional approval by the ABA.

Arthur Winfield MacLean was succeeded as dean by his longtime colleague, A. Chesley York, who had been associated with Portia Law School since he began teaching there in 1909. Here is York (far right) at the 1943 commencement exercises with dignitaries and honorees, including Arthur V. Getchell (far left), a faculty member who later became a trustee and president of the law school. (Courtesy of the Boston Public Library.)

A major factor in increased enrollments in the postwar years was the GI Bill, which granted educational benefits to veterans. Because the recipients were predominantly male, men quickly outnumbered women at Portia Law School after the war. Significant numbers of women did not apply again until the 1970s. This is a photograph of Alfieri Pruiciotta, one of the first men to enter Portia on the GI Bill in 1945.

Pruiciotta received his degree from York at the 1949 commencement exercises. He was one of the nation's first GI Bill recipients to receive a degree. Of the 44 candidates receiving the bachelor of laws degree in that year, 39 were men. This was the first year in the school's history in which male graduates outnumbered women.

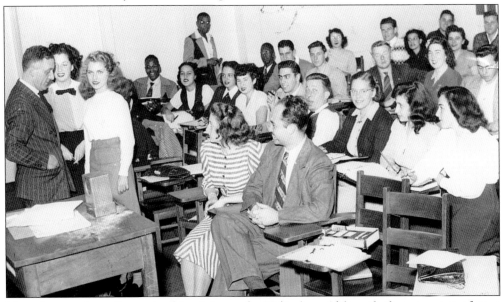

Note the number of men in this picture of a 1945 class. Although the presence of men was relatively new, the presence of African American students was not. African American women had attended Portia since the law school's early days. Blanche E. Braxton (class of 1923) was admitted to the Massachusetts bar in 1923. Five African American women graduated in 1927. In 1932, Dorothy Crocket (class of 1931) became the first black woman admitted to the Rhode Island bar.

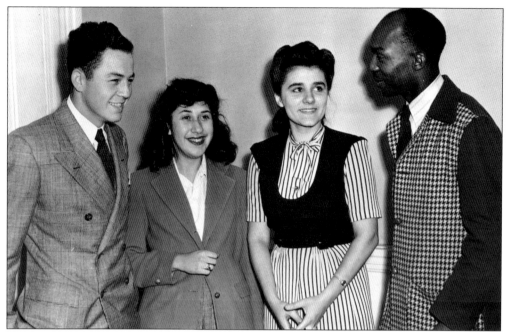

Here are the officers of the class of 1947. That class, which had entered in wartime, included only eight graduates, four of them men. The 1948 graduating class, also with eight, had seven women. That was the last graduating class until 2001 in which women outnumbered men. (Courtesy of the Boston Public Library.)

By the late 1940s, the law school's student body was largely male. Ironically, that was also when the institution stopped using the Calvin Coolidge Law School designation for the men's program and returned to calling the entire law program Portia Law School, a name originally chosen because of Portia's unique character as an all-women law school.

Despite the predominance of men among its students, Portia continued to remember and honor its women graduates. One of these was Catherine E. Falvey (class of 1937). After graduating from Portia, Falvey entered politics in Somerville and in 1940 was elected as the youngest member of the Massachusetts House of Representatives. After reelection in 1942, she resigned her seat to take an officer's commission in the army. (Courtesy of the Boston Public Library.)

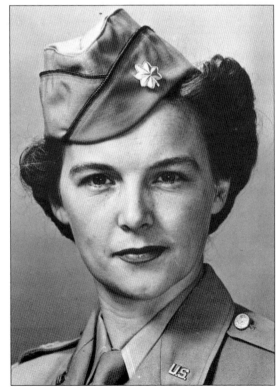

During the war, Falvey rose to the rank of major. When the Nuremberg war crimes tribunal was established to try Nazi war criminals, she was the only woman named to head a department of the United States legal staff during the trials there. Portia presented her with an honorary degree in 1946. (Courtesy of the Boston Public Library.)

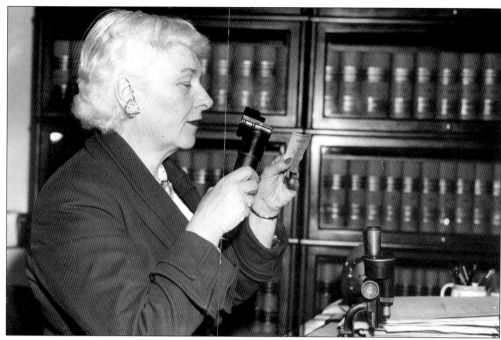

Another Portia Law School graduate who gained fame in this period was Elizabeth McCarthy (class of 1923). Born in South Boston, she earned a degree at Vassar College before entering Portia. Rather than practice law, she became a nationally known handwriting expert. From the 1930s through the 1960s, she appeared as an expert witness in hundreds of cases around the country. Here she is testifying in an inquiry into the signatures on mayoral nomination papers in Boston in 1967. (Courtesy of the Boston Public Library.)

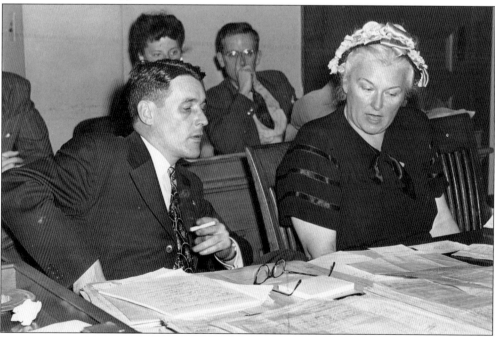

Anna E. Hirsch of Dedham became interested in the law through her work as an assistant registrar of probate after her graduation from Dedham High School. She graduated from Portia in 1928. In 1954, she was elected registrar of probate of Norfolk County, only the second woman in Massachusetts to be elected to countywide office. She was resoundingly reelected in 1960. In 1966, she became a trustee of Portia and was a strong supporter of the move to achieve ABA accreditation. In 1983, she was elected president of New England School of Law. This is a photograph of her in 1954 being sworn in as registrar of probate by Gov. Christian Herter. (Courtesy of the Boston Public Library.)

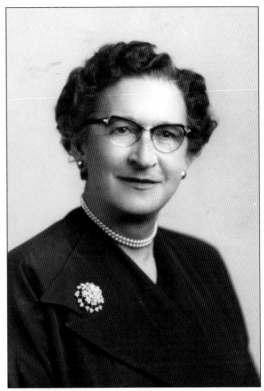

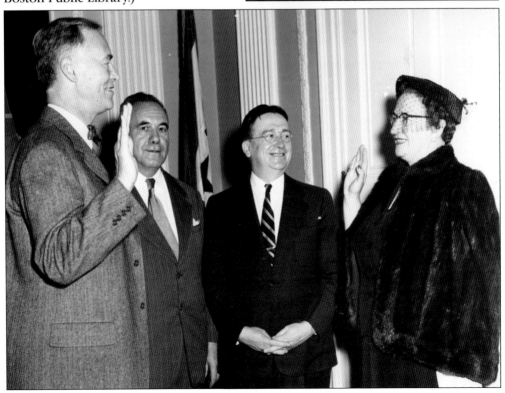

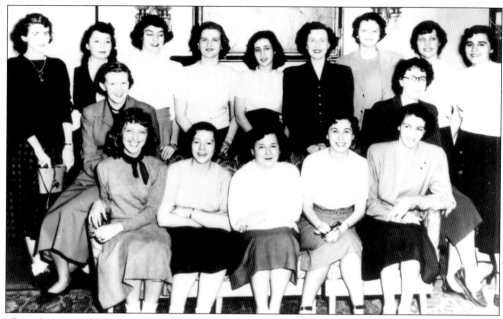

This photograph captures a gathering of women enrolled in Portia Law School and Calvin Coolidge College in 1950. In that year, the law school gave degrees to 84 graduates; only eight were women. Portia's enrollment declined after 1950. From 1952 until 1960, the graduating class was not larger than 40. During those years, the institution was supported primarily by revenue from the college. (Courtesy of Georgia Ypsilantis.)

Dean A. Chesley York died in 1952, and he was succeeded by Margaret H. Bauer, a 1937 graduate of Portia who had served the school since her graduation, first as an administrator and then as a college faculty member. Bauer, a native of North Carolina, had earned a doctorate in education while working for Portia and was the unanimous choice for the deanship. (Courtesy of the Boston Public Library.)

In 1958, Portia purchased the adjoining building at 47 Mount Vernon Street, seen on the left of this photograph. That building had housed the Northeastern University School of Law (originally the YMCA law school), another part-time law school, which closed temporarily in 1956. In the 1950s, enrollment in Portia Law School was less than 150, but a larger number of students attended Calvin Coolidge College, thus requiring more space.

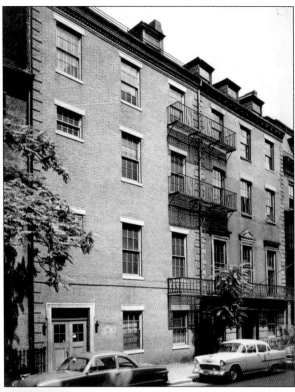

Bauer resigned the deanship in 1962. With her resignation, the school lost its last full-time connection to the MacLean era. She was succeeded by Guy V. Slade, pictured here, who joined the faculty in 1947.

41

By the 1960s, it was becoming clear that Portia Law School would have to change. It could no longer survive as an inexpensive "school of opportunity" but would have to compete for students with the other nationally accredited law schools in Boston. In 1963, the board of trustees directed the law school administration to embark on a program designed to obtain accreditation from the ABA "in the relatively near future." The chairman at that time was Amos L. Taylor (left) and the president was Arthur V. Getchell (below). Getchell first joined the faculty in 1931 and became a trustee in 1952. Taylor had been a trustee since 1937 and chairman since 1952. (Courtesy of the Boston Public Library.)

A further step toward bringing Portia into the mainstream of law schools was the 1965 founding of the *Portia Law Journal*, now the *New England Law Review*. Pictured here is an early editorial board. The law school's second journal was established in 1974 under the tutelage of Prof. Richard Child. The *New England Journal on Prison Law* (now the *New England Journal on Criminal and Civil Confinement*) was then the nation's only journal devoted to confinement law. The Portia class of 1965 included 68 graduates but only two women. From 1954 to 1973, no Portia graduating class included more than five women. By 1978, there were 68 women in the graduating class of 260 (26 percent), and their numbers were increasing nearly every year.

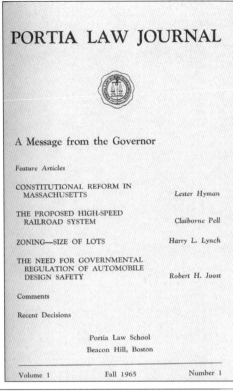

PORTIA LAW JOURNAL

A Message from the Governor

Feature Articles

CONSTITUTIONAL REFORM IN
 MASSACHUSETTS *Lester Hyman*

THE PROPOSED HIGH-SPEED
 RAILROAD SYSTEM *Claiborne Pell*

ZONING—SIZE OF LOTS *Harry L. Lynch*

THE NEED FOR GOVERNMENTAL
 REGULATION OF AUTOMOBILE
 DESIGN SAFETY *Robert H. Joost*

Comments

Recent Decisions

Portia Law School
Beacon Hill, Boston

| Volume 1 | Fall 1965 | Number 1 |

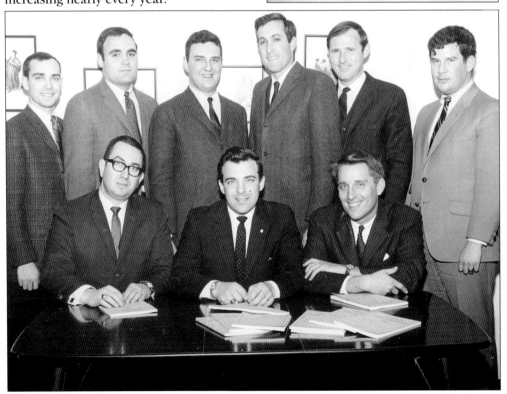

In 1966, two new members were added to the Portia Law School corporation and board of trustees, Judge James R. Lawton (class of 1953) of the Plymouth County Probate Court (above) and Anna E. Hirsch (class of 1928), the former registrar of probate for Norfolk County. With the addition of Dr. Harold Udell (at left), who earned a doctorate in 1960 from Calvin Coolidge College, the number of trustees increased to seven, and for the first time in the history of the school, three of them were graduates of the institution. This began a period of increasing alumni involvement in the law school. Lawton became the chairman of the board in 1969. From that position, he led the drive for ABA accreditation.

In 1966, Dean Guy V. Slade
resigned and was succeeded
by Walter J. Kozuch Jr., who
held the deanship until 1971.
It was clear that ABA approval
required upgrades to the faculty,
library, and facilities, as well as
the academic program. Calvin
Coolidge College, whose tuition
revenue had supported the law
school during low enrollments
in the 1950s, was now requiring
revenue infusions from Portia,
and the college was therefore
closed in 1968.

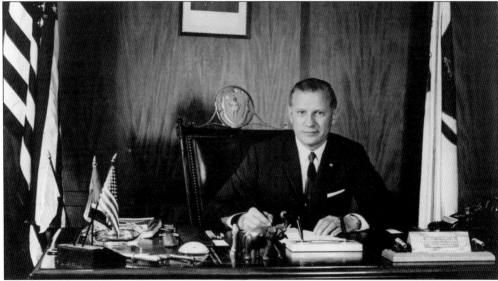

With enrollments declining once again, the new board of trustees pushed to speed
the process of achieving national accreditation. It first changed the school's governing
structure, petitioning the legislature to amend the 1919 charter. The amendment,
approved in 1968 and signed by Gov. John Volpe (seen here), increased the corporate
board from seven members to 11 and provided that replacements would henceforth be
elected by the school's alumni instead of being chosen by the remaining incorporators.
(Courtesy of the State Library of Massachusetts.)

Key to achieving ABA approval was the creation of a full-time faculty. Portia Law School's professors had always been practicing lawyers who taught part time. The trustees moved slowly in departing from that model, concerned that the much higher cost of a full-time faculty would undermine the school's affordability. In 1967, Robert E. O'Toole, pictured here, was hired as Portia's first full-time faculty member who did not also occupy an administrative position.

Cornelius Daly joined the part-time faculty in 1967. In 1969, he was hired as the fifth full-time faculty member. The others after O'Toole were Colin W. Gillis (in 1967), Timothy J. Cronin (in 1968), and Richard J. Gould (in 1968). Like Daly, Gillis had been a member of the part-time faculty for several years before his full-time appointment. In subsequent years, Gillis, Daly, and Cronin all served as dean.

As new full-time faculty were added, the part-time faculty relinquished the large-enrollment courses to them, but many of them remained on the faculty, teaching smaller, more specialized courses. Pictured here in 1967 are James R. DeGiacomo (at right) and Salvatore Fabiano (below), both of whom continued teaching at the law school for many years after that. DeGiacomo became one of Boston's best-known trial lawyers, a name partner in the firm of Roche, Carens, and DeGiacomo; he also served as chairman of the Massachusetts Board of Bar Overseers. DeGiacomo continued teaching at the law school until 2001. Fabiano began teaching at the law school in 1948 and also served briefly as the school's placement director. He continued on the part-time faculty until 1980.

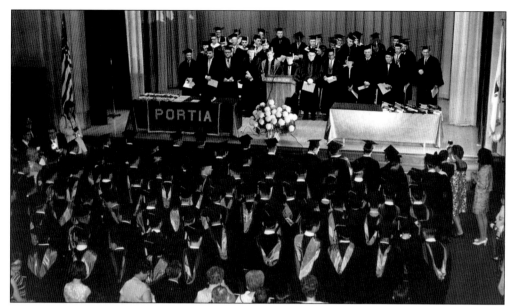

In 1968, the last commencement under the name Portia Law School took place in New England Life Hall. Including three women, 74 graduates received degrees. That was about the average number of graduates throughout the 1960s, but by 1968, enrollment in the law school was dropping again. Only 37 graduated in 1970 and only 29 in 1971. In order to meet ABA requirements, the school had raised admission standards, narrowing the pool of prospective students.

In February 1969, the ABA formally granted provisional approval to Portia Law School. In the same month, the school's name was changed to New England School of Law. The school was now presenting its face to a new, national audience, and the trustees wanted it to present a new name as well. The new name appears here at commencement, along with the diplomas of the graduating class.

Three

GROWTH AND TRANSFORMATION
1969–1988

Under the leadership of board chairman James R. Lawton, New England School of Law made great progress during this period. In 1973, New England School of Law received full approval from the ABA, but the transformation of the school was only beginning. Enrollment, which had fallen to 154 in 1968 before provisional accreditation, had climbed to 480 in 1971. Calvin Coolidge College, which had sustained the law school in the 1950s, had become a drain on resources and was closed in 1968, allowing the law school to expand into the college space at 45 Mount Vernon Street.

But enrollment continued to grow, and more space was needed, both for classes and for the expanding full-time faculty. In addition, the school had hired its first full-time librarian in 1970, and the collection was growing quickly, also requiring more space. In 1972, the school sold its property at 45–47 Mount Vernon Street and purchased a much larger building at 126 Newbury Street in Boston's Back Bay. The faculty grew from seven full-time members in 1969 to 15 in 1972.

New England School of Law operated for nine years in the Newbury Street building, and each year brought added enrollment, faculty, and library collection. Again needing more space, the school moved in 1980 to its present location on Stuart Street. The clinical program, which was begun by students in 1971, was greatly expanded in the 1980s. Computer technology was installed throughout the institution. The library grew and modernized. The full-time faculty expanded to 27 members by 1983. By the mid-1980s, it included men and women who hailed from around the country, and several were beginning to publish scholarship that attracted national attention.

The law school was also drawing local notice through its large events. Beginning in 1970, the Law Day observance brought in nationally prominent speakers, and by the 1980s, many of its commencement speakers were also national figures. When the school celebrated its 75th anniversary in 1983, Vice Pres. George H. W. Bush was the dinner speaker.

In the years after provisional accreditation, New England School of Law was transformed into a large, modern, national law school.

In 1971, Prof. Robert E. O'Toole succeeded Walter Kozuch as dean. O'Toole was the dean during the next phase of the school's accreditation, the movement from provisional to full ABA approval. That was to require more changes, including moving the law school from its historic location on Beacon Hill. O'Toole is third from the left in the first row of this photograph of full-time and part-time faculty at the 1974 commencement.

In 1972, the Mount Vernon Street property was sold to Suffolk University and the law school purchased and moved into this building at 126 Newbury Street in Boston's Back Bay neighborhood. The school occupied the top five floors of the six-story building, but the city's use permit required that part of the ground floor be leased for commercial use. Even so, the building provided much more usable space than the Mount Vernon Street facility.

The ABA granted full accreditation to the law school in 1973. Trustee chairman James R. Lawton (right) had worked tirelessly to achieve this. Lawton, who served as first justice of the Plymouth County Probate and Family Court in Brockton for most of his 31 years on the bench, joined the board in 1966 and was elected chairman in 1969. During his 39-year tenure as chairman, the law school also received approval from the Association of American Law Schools, moved to its current location on Stuart Street, and gained a national reputation. Lawton is shown here at the 1974 commencement shortly after the school received ABA approval. With him are Prof. C. Ronald Chester (center) and Congressman Thomas P. (Tip) O'Neill, speaker of the U.S. House of Representatives, who received an honorary degree at the commencement.

Dean Robert E. O'Toole resigned in 1974 and was succeeded by Colin W. Gillis. Gillis had been a member of the part-time faculty for five years before joining the full-time faculty in 1967. Here is Gillis (right) with trustee chairman James R. Lawton in 1975.

In 1970, the school began an annual observance of Law Day, a celebration of the rule of law proclaimed by Pres. Dwight D. Eisenhower in 1958. The event has usually included a formal dinner, with a head table of judges and other leaders of the legal community and a distinguished speaker, followed by a dance. As can be seen from this photograph of students at the 1988 Law Day celebration, the event has also provided an opportunity to dress up.

In 1973, the law school received its first
visit from a justice of the U.S. Supreme
Court. Three New England students
had approached Justice William O.
Douglas personally during a speaking
engagement at Tufts University the
previous fall and secured his agreement
to be the 1973 Law Day speaker.
Two of those students are pictured
above. From left to right are Douglas
Beach, 1973 Law Day chairman; Chief
Justice Walter H. McLaughlin of the
Massachusetts Superior Court; Douglas;
and Levi Trumbull, Student Bar
Association president. More than
650 people attended the event, and it
had to be moved to a larger venue.

The 1974 Law Day observance included activities beyond the dinner. The student Law Day committee arranged for New England School of Law students to speak at local high schools and scheduled a day of seminars on recent developments in the law, taught by faculty and sponsored by the alumni association. More than 100 attorneys attended the seminar program. Above, Student Bar Association president George Sciarrino and Law Day chairman Michael Williams speak to a class at Boston's Copley High School. In the photograph below, Prof. Michael Wheeler conducts a seminar on no-fault divorce.

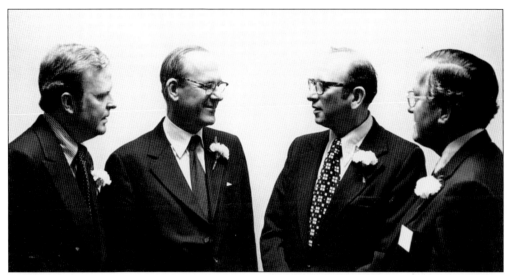

The Law Day speakers in 1974 and 1975 were major figures in the Watergate investigation, which culminated in Pres. Richard Nixon's resignation in August 1974. The 1974 speaker was Sam Dash, chief counsel to the Senate Watergate Committee, then holding the hearings that led to Nixon's resignation later that year. Dash (second from right) is shown above with, from left to right, Dean Robert E. O'Toole, Pres. A. Leavitt Taylor, and Chairman James R. Lawton. The 1975 speaker was Judge John J. Sirica, whose trial of several of the Watergate defendants had brought the scandal to light. Sen. Sam Ervin, the chairman of the Senate Watergate Committee, also attended the 1975 event as a special guest, "to hear Judge Sirica's remarks." In the photograph below is Ervin (right) with Frank A. Scioli, then the school's administrator for fiscal affairs.

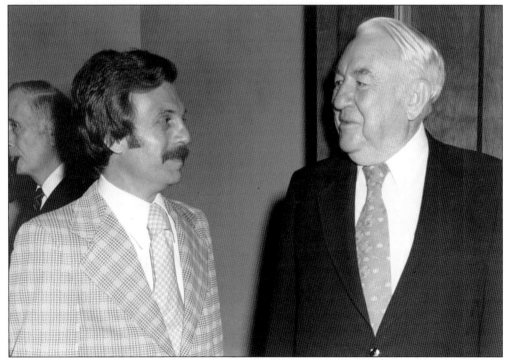

The committee's hearings were nationally televised and both Sen. Sam Ervin (right) and Judge John J. Sirica (left) had achieved celebrity status by 1975. It was the persuasion of the two student Law Day chairs, Carol L. Weidman (second from left) and Alane C. Probst (third from left), shown here with their guests, that brought them to New England School of Law.

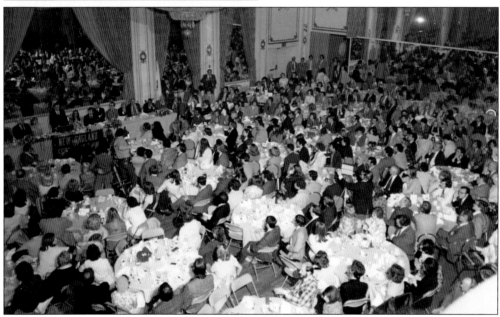

This photograph, taken at the 1975 Law Day dinner, gives an idea of the large number of people attending. Aside from the head table, most of the attendees were students and graduates. The school's graduating class did not reach 100 until 1973, so this turnout indicates both the school's success in enrolling more students and the popularity of its Law Day observance.

In the 1970s, the law school introduced a new, annual alumni event, the Dean's Reception. Alumni from all years are invited to attend, along with the members of the graduating class. Each Dean's Reception recognizes people who have contributed to the progress of the law school. In this 1978 photograph, Chairman James R. Lawton presents a portrait to Judge A. David Mazzone of U.S. District Court, who for many years was a member of the adjunct faculty.

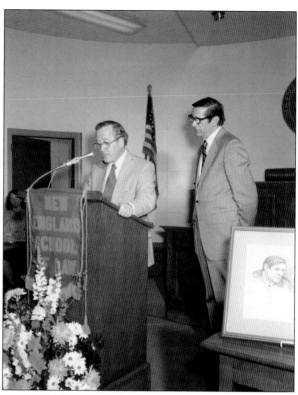

An innovation of the 1970s was the Special Part-Time Program, for parents with child-care responsibilities. Open only to a few qualified students, the program allows them to take courses out of order and to take up to six years to complete their degree requirements. During its early years, the program was seen as a way of making a law degree accessible to mothers, but by the 1990s, it included men as well.

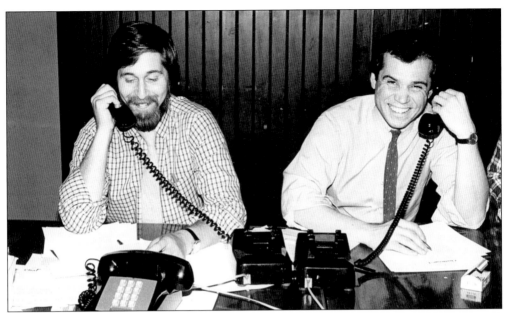

Always primarily dependent on tuition income, the law school now needed additional revenue so that it could pay the costs of the upgrades necessary to achieve ABA approval without charging an unaffordable tuition. Here are two photographs of students staffing a "phonathon" conducted in the Newbury Street building in the 1970s. Above, on the left is Leonard P. Zakim (class of 1978), who went on to become regional director of the Anti-Defamation League and an important religious and civil rights leader. Boston's Leonard P. Zakim Bunker Hill Bridge was named for him after his death in 1999. To his right is classmate James P. Rosencranz (class of 1978). (Courtesy of George W. Gardner.)

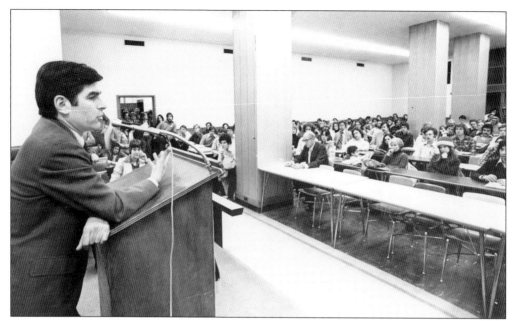

In April 1977, Massachusetts governor Michael S. Dukakis spoke at the law school. Here he is in the largest classroom of the Newbury Street building. The informal style he displays here made him famous during the blizzard of 1978 several months later, when he kept the snowed-in public informed by appearing on television, wearing a sweater and urging calm.

Colin Gillis resigned as dean in 1977 and the trustees and faculty agreed to conduct the first nationwide dean search in the law school's history. During the search, from 1977 to 1978, Prof. Cornelius Daly served as acting dean. Daly had joined the full-time faculty in 1969. He is on the right in this photograph from the 1978 Dean's Reception. The others are, from left to right, Pres. A. Leavitt Taylor, Chairman James R. Lawton, U.S. District Court judge A. David Mazzone, and Eleanor Mazzone.

In 1978, Thomas C. Fischer was chosen as dean after a nationwide search. Fischer had been assistant executive director of the American Bar Foundation and associate dean of the University of Dayton School of Law. He was the first dean in the history of the law school who had not previously been employed by the school in any capacity. Here he is shown on the left with New England School of Law president A. Leavitt Taylor.

The 1979 Law Day speaker was U.S. senator Paul Tsongas, pictured on the left being introduced by Fischer, who is flanked by the Law Day chairs. On the far right is Chief Justice Edward Hennessey of the Massachusetts Supreme Judicial Court. Twenty-nine years later, U.S. congresswoman Niki Tsongas, the senator's widow, spoke at a Law Day banquet.

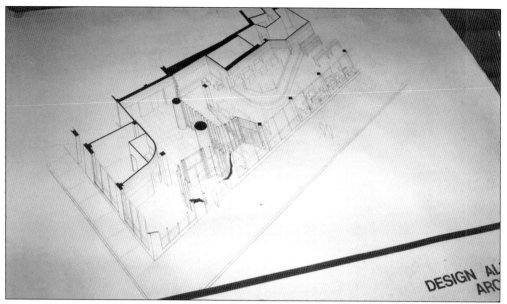

By the late 1970s, the law school had outgrown the Newbury Street building. After provisional ABA approval in 1969, enrollments increased dramatically. There were 117 graduates in 1973, up from 41 in 1972. By 1976, the graduating class had increased to more than 250. In 1978, the law school purchased a larger building at 154 Stuart Street. After renovations were complete, the school moved in 1980. Here is the plan for the lobby of the new building.

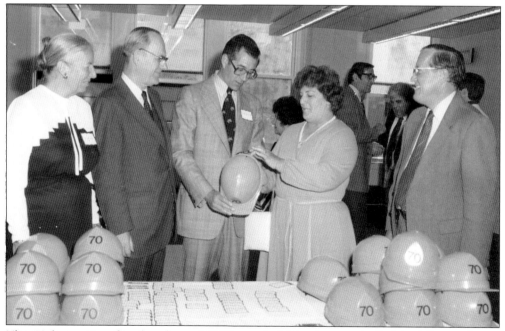

The 10th reunion for the class of 1970 was held in the nearly finished Stuart Street building. Here Fischer, flanked by Chairman James R. Lawton and his wife, Jeanne, on the right and Pres. A. Leavitt Taylor and his wife, Jean, on the left, inspects the commemorative hard hats.

Classes were held in the Stuart Street building in the fall of 1980, and a dedication ceremony was scheduled for the spring of 1981. Here Chief Justice Edward Hennessey (left) of the Massachusetts Supreme Judicial Court helps Chairman James R. Lawton to unveil the dedication plaque on May 2, 1981.

At the building dedication, library director Frank Bae was honored for his contributions to the new building. Bae joined the faculty in 1970 and engineered the growth of the library from the practitioner collection of the Portia Law School days to the large, well organized and well-staffed library that then occupied more than two floors of the new building. Professor and former dean Robert O'Toole (right) presented the award.

Under Bae's direction, the school's library had grown from the small collection in the Mount Vernon Street days to 155,000 volumes and equivalents by 1982. Visible from the street and open to all members of the bar, with a highly regarded staff, the library had become a major attraction of the law school. Here Bae consults with research librarian Richard Ducey (class of 1977), who is now the library director at the University of Tulsa College of Law.

The classroom space in the Stuart Street building was a major improvement over the Newbury Street facility. Here Prof. Daniel Ticcioni teaches a class in one of the large, well-lighted, acoustically advanced, amphitheater-style classrooms in the early 1980s.

The security staff are the first people students and visitors encounter when they enter the law school, and they are often popular. Ted Campo was the legendary and well-loved building superintendent at the Newbury Street building. Dominic Mannarino was his successor, shown above receiving an award from students in 1980, when the law school was still on Newbury Street. Presenting the award is Claire Campo (class of 1981), Ted's daughter. Another popular security staffer was Enzo Iarrabino, who retired in 2002. On the right, in the photograph below, he speaks with Controller Frank Scioli in 1988.

The New England School of Law clinical programs began a period of strengthening and growth in 1981 when Philip Hamilton joined the faculty as director. The New England School of Law Legal Services office, founded by students in 1971 and located in an office building in Malden (called the "Malden Clinic"), was reorganized and a new supervision protocol was established. Now called the Clinical Law Office, it was relocated to rented space at 75 Kneeland Street (right), only four blocks from the law school in 1986. The space was convenient for both faculty and students and only a short trip on the Orange Line train for old clients from Malden. In the photograph below, Hamilton confers with the contractor during the build-out of the new space.

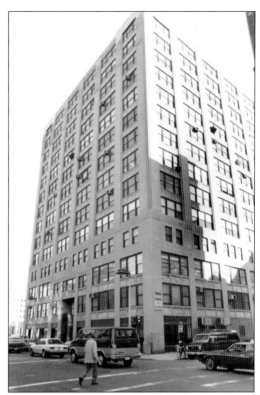

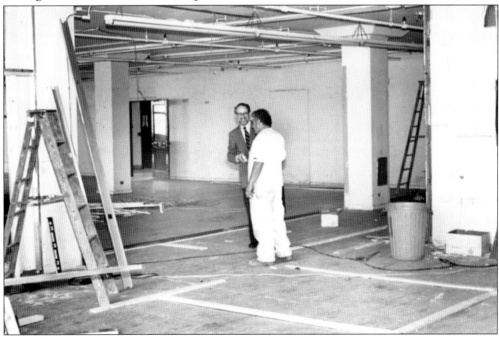

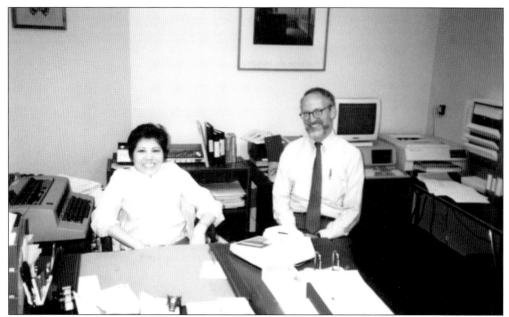

In 1986, Maria Chang joined the clinical law office as office manager. With her knowledge of Chinese languages and her experience in the community, she brought a wide range of skills to assist clients, students, and faculty. The photograph above is of Chang and Prof. Philip Hamilton in the clinical law office. Below, Chang is helping two students learn the office computer system. Besides the in-house clinic in the Clinical Law Office, the law school developed externship clinics in the 1980s in criminal prosecution and defense, administrative law, mental health law, immigration law, taxation, and government work. Now directed by Prof. Russell Engler, the school's clinical programs have expanded further and enroll a majority of the school's students.

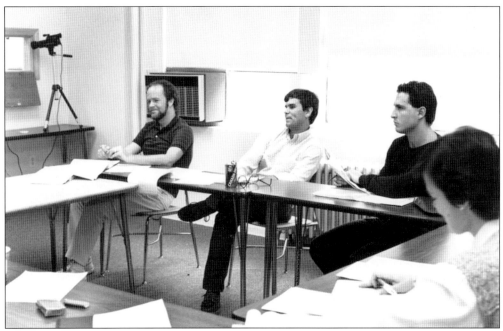

This is a clinical seminar being conducted in the Clinical Law Office in the mid-1980s. Note the video camera pointing through the opening into the adjoining room, allowing students in the seminar to observe a simulated client interview taking place next door. Video has always been heavily used in the law school's clinical teaching.

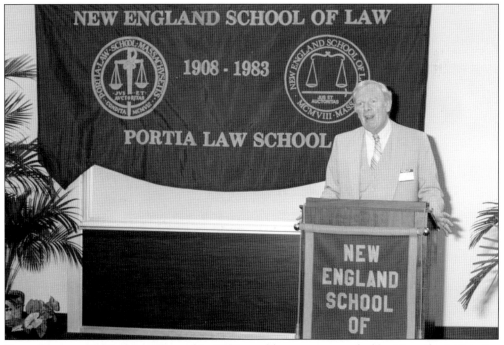

Dean Thomas C. Fischer resigned in 1981, and he was succeeded by Timothy J. Cronin. Cronin had been a member of the faculty since 1968 and was Fischer's associate dean. Here he addresses the 1983 alumni reunions.

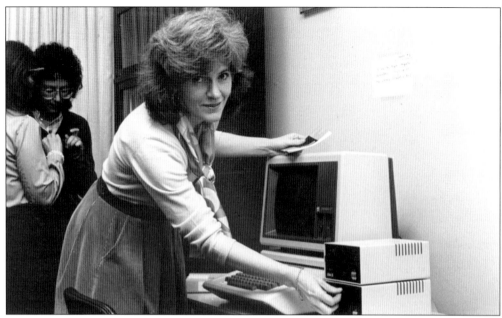

Mary Joe Frug joined the faculty in 1981. She was a major contributor to a new curricular focus on women's issues in the law, both nationally and at the law school, where an increasing number of students were women. She published articles and an innovative casebook on the subject. She was also instrumental in speeding the computerization of the library and the faculty offices. She persuaded Dean Timothy J. Cronin, shown with her below, to make New England School of Law only the second Boston-area law school (after Harvard Law School) to join the newly formed national Center for Computer Assisted Legal Instruction (CALI). She often rode a bicycle to the school from her home in Cambridge. Frug was killed by an unknown assailant in 1991 while on sabbatical.

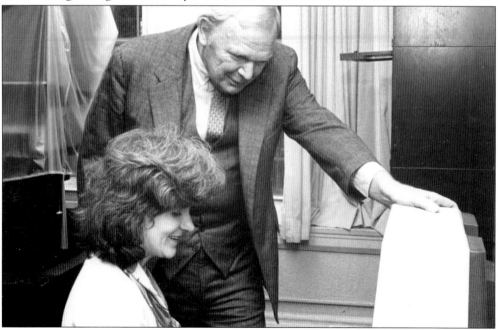

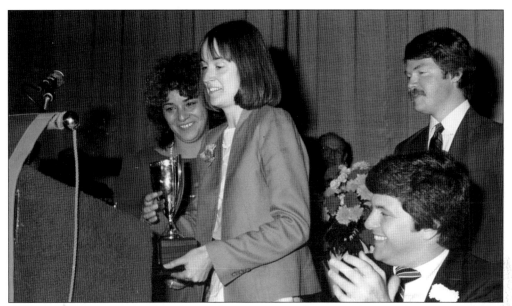

At the 1982 Law Day dinner, the students presented an award to Anne Acton, then the assistant director of the library. Acton had already earned a master of library science degree when she joined the library staff in 1974. She received her Juris Doctor from the law school in 1980. By 1982, she had become the assistant to Prof. Frank Bae, the library director, and worked with him to make the library one of the outstanding departments of the law school. Acton became the director of the law library when Bae retired in 2005.

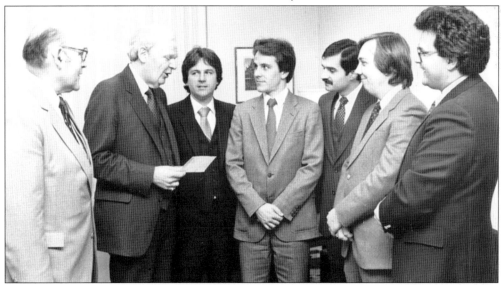

After the charter amendment of 1968, the alumni assumed a more prominent role in the direction of the law school, and with the school's rapid growth, many of those involved were recent graduates. Here Cronin (second from left) meets with the officers of the alumni association in the early 1980s, including future dean of the law school John F. O'Brien (class of 1977, third from left), future chairman of the board of trustees Martin C. Foster (class of 1980, second from right), and the law school's first alumni director Andrew J. Calamare (class of 1981, right). (Courtesy of Matthew M. Delaney III.)

In 1984, the law school began to hold an annual fall dinner for students and alumni of color. The event was sponsored jointly by the school and the Minority Students Association. The Minority Students Association dinner has grown to a major event, drawing alumni from around the country.
In this photograph, alumnus Benny Haynes (class of 1978) addresses the second annual dinner in 1985.

The law school's 75th anniversary took place in 1983, and it provided many opportunities to look back and to celebrate the school's progress. In the previous 20 years, it had made the transition from a small, state-accredited, largely part-time institution—a proud example of a dying breed of law school—to a large, nationally accredited, full-time institution in an up-to-date facility, fully in the mainstream of American legal education.

The 1983 Dean's Reception was the kickoff event of the 75th anniversary year. It was held in the library and lobby of the law school. Here from left to right are Chairman James R. Lawton, Gov. Edward J. King, Attorney Gen. Francis X. Bellotti, and Dean Timothy J. Cronin.

This is a photograph of Anna E. Hirsch at the 75th anniversary dinner. To her right is Cronin and to his right is Chief Justice Edward Hennessey of the Massachusetts Supreme Judicial Court. Over Cronin's shoulder, King can just be seen. A member of the corporation and a trustee since 1966, Hirsch (class of 1928) was elected president of the law school in 1983.

The 75th anniversary celebration culminated in a gala dinner, attended by many prominent judges and other luminaries of the Massachusetts legal and governmental communities. Vice Pres. George H. W. Bush was the keynote speaker. He was presented with a New England School of Law sweatshirt at the event. Barbara Bush is on the left.

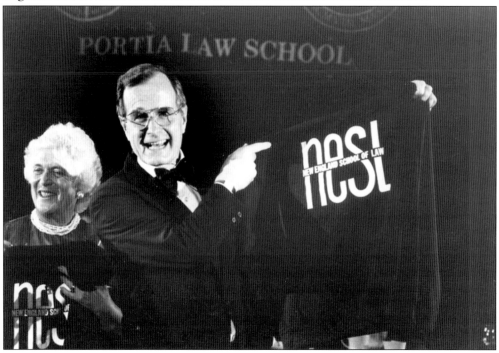

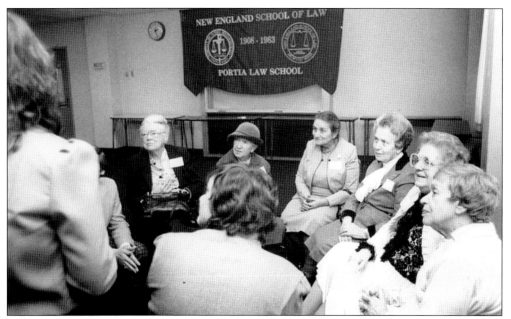

The 1983 Law Day events included a reception in honor of graduates of the early Portia Law School classes. The women in this photograph received their degrees from the law school in the 1920s and 1930s when it was an all-women institution. In many years, the law school has also honored an early Portia graduate with an honorary degree at graduation.

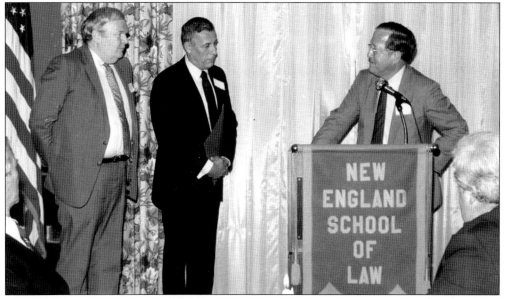

John R. Simpson graduated from Portia Law School in 1964, when the school's faculty was still part-time. He used his legal training to pursue a career in law enforcement rather than practicing law. In 1981, he was appointed director of the U.S. Secret Service, a position he held under two presidents. The law school honored him at this alumni event in 1982. Dean Timothy J. Cronin is on the left and Chairman James R. Lawton is on the right.

John R. Simpson (class of 1964, second from left), director of the U.S. Secret Service, delivered the 1983 commencement address, the first of the school's graduates in modern times to do so. He is pictured here with his wife, Gerry, their daughter Jane, and Chairman James R. Lawton. Simpson was the director of the Secret Service until 1992 when he was named to the U.S. Parole Commission. He has been a trustee of the law school since 1983.

Frank Scioli (left) joined the staff of Portia Law School in 1958 as the assistant treasurer. His careful husbanding of the school's resources brought him steady advancement. When this photograph was taken at the 1983 alumni reunion, he was the school's administrator for fiscal affairs. He was honored at the 1998 Dean's Reception. Now the chief financial officer, he is the longest-serving law school employee, having worked through half the life of the institution under 10 deans.

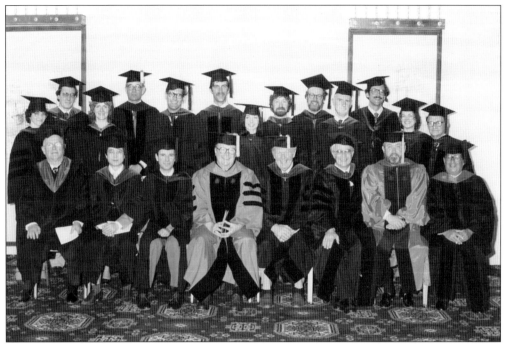

By 1983, the full-time faculty had grown to 27 members, an increase of 12 positions since 1976. Here 17 of them pose at the 1983 graduation along with several members of the adjunct faculty.

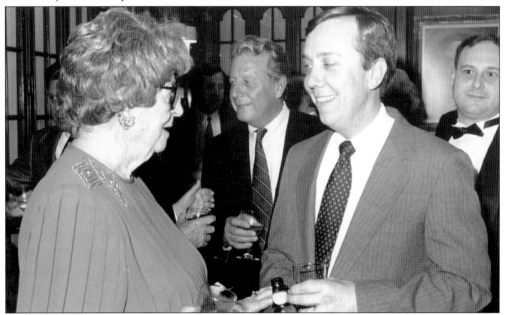

In 1983, Anna E. Hirsch (class of 1928) succeeded A. Leavitt Taylor as president of New England School of Law. She was the first graduate of the school—and the first woman—to achieve that office. In this photograph, she shares a laugh with trustee Martin C. Foster (class of 1980). When Hirsch died in 1997, Foster succeeded her as president. In 2007, he was elected chairman of the board of trustees.

This is a photograph of Dean Timothy J. Cronin with Prof. C. Ronald Chester in the early 1980s. In 1985, Chester published *Unequal Access: Women Lawyers in a Changing America*, a book describing the situation of women in the legal profession in the early 20th century. His book was based in part on interviews with several Portia Law School graduates from the 1920s and 1930s. Some of the material in this book is derived from his research.

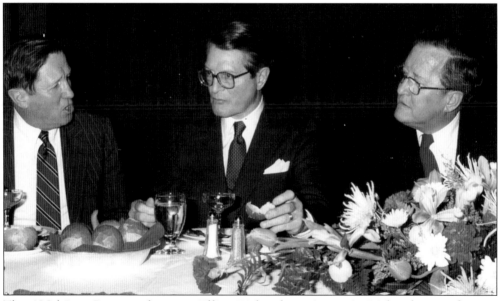

The 1984 Law Day speaker was Elliot Richardson (center). Richardson, a former Massachusetts attorney general, had been appointed to four federal cabinet positions in the 1970s. Here he converses with his cousin, Judge Maurice Richardson (left) of the Dedham District Court, who was, and still is, a member of the school's adjunct faculty. At the time of the photograph, Richardson taught legal writing and was the assistant director of the school's legal writing program.

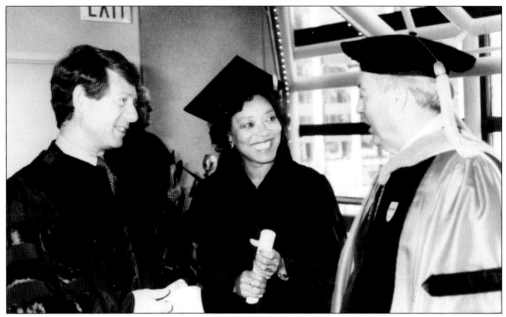

U.S. Magistrate Judge Joyce London Alexander (class of 1972) received an honorary degree in 1984. Alexander was appointed a magistrate judge in 1979, the first African American woman to achieve that position. In 1996, she became the first African American to be appointed chief United States magistrate judge. Here she is shown with 1984 commencement speaker Ted Koppel (left) and trustee Charles Hamilton.

In 1985, the Law Day speaker was civil rights leader Julian Bond, who at that time was serving his sixth term as a member of the Georgia senate after having served four terms in the Georgia House of Representatives, which had at first refused to seat him. At the time of Bond's Law Day appearance, the law school had only a small percentage of minority students and was beginning to make efforts to change that. Bond (left) is shown here with Chairman James R. Lawton.

By the 1980s, the school's Law Day celebration had become a very big event, drawing hundreds of students and alumni every year as well as many prominent judges and other members of the local and national legal communities. Students continued to do much of the logistical and support work necessary to put on such an event, and many students volunteered every year. This is a photograph of the 1989 Law Day committee.

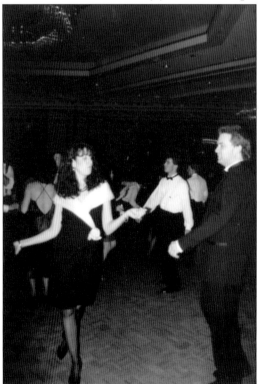

A major reason why the school's celebration of Law Day has had such an attraction for students is that it combines the serious with the festive. The dinner and speech are always followed by a dance, the Barrister's Ball, carrying the festivities far into the night. Here students trip the light fantastic at the 1992 ball.

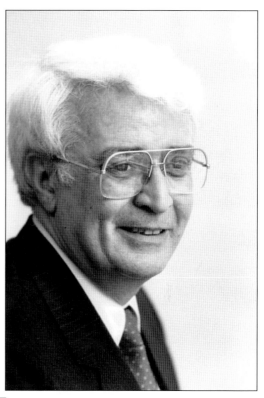

Timothy J. Cronin resigned the deanship in 1986 and was succeeded by his associate dean, Kenneth R. Evans (right), who had joined the faculty in 1980. He chose John F. O'Brien (below) as his associate dean. O'Brien had graduated from the law school in 1977 at the top of his class and had joined the office of the chief counsel of the Internal Revenue Service. He became the president of the school's alumni association and was appointed to the board of trustees in 1978. He resigned from the trustees and joined the faculty in 1985.

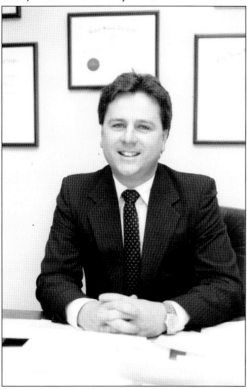

Since its inception, the law school has always offered opportunity to people who could not attend law school full time. Many of those have been working men and women who were the parents of small children. In a commencement tradition dating from the 1980s, graduates bring their youngsters with them to receive their diplomas. In this 1984 photograph, graduate and son are receiving dad's diploma from Pres. Anna E. Hirsch and Dean Kenneth R. Evans.

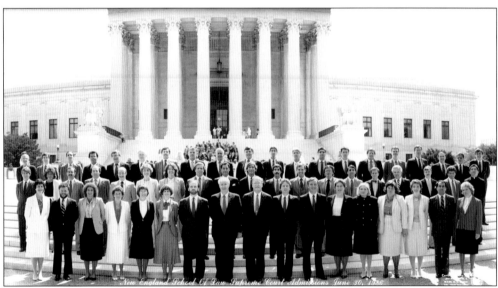

In the mid-1980s, the school inaugurated a new alumni function, a weekend in Washington, D.C., including a reception, a buffet breakfast, and a sightseeing tour, culminating in formal admission to the bar of the U.S. Supreme Court during an open session of the court on Monday morning. This is one of the first groups to participate, in 1986. The event has continued on a biannual basis since then.

The Law Day speaker in 1987 was Rudolph Giuliani, then the nationally prominent U.S. attorney for the southern district of New York. He was awarded an honorary degree, and here he receives the hood from Evans while Hirsch reads the proclamation.

With an alumnus as head of the Secret Service, the law school had a link to the federal government in the 1980s. Secretary of the treasury James Baker was the 1986 commencement speaker, followed the next year by Edwin Meese III, the attorney general of the United States. Here Chairman James R. Lawton introduces Meese.

At the 1987 Dean's Reception, the school honored Susan J. Crawford (class of 1977), then the general counsel of the department of the army. In 1989, Pres. George H. W. Bush appointed her inspector general of the U.S. Department of Defense. From 1991 to 2006, she served on the U.S. Court of Appeals for the armed forces, the last five years as chief judge. In 2007, she was named the convening authority for the United States military commissions, with responsibility for the trials at Guantanamo Bay.

This 1987 photograph shows professor and former dean Robert E. O'Toole with his wife, Frances O'Toole (class of 1988, right), and Carol Palmer, the longtime administrative assistant to the deans who served as O'Toole's secretary when he was dean from 1971 to 1974. Robert O'Toole, the school's first full-time faculty member, retired in 2003.

Another of the school's major traditions is the senior class party, always held early in the week of graduation. The event takes place in an attractive public venue and is the school's send-off salute to the graduating class, a last opportunity to gather with classmates and professors before graduation. This photograph is from the 1987 senior class party, held in Boston's Quincy Market.

In 1992, a storm prevented the scheduled speaker from landing in Boston to deliver the Anna E. Hirsch Lecture. Wayne Budd (third from right), then the deputy attorney general of the United States and a longtime friend of the school who had just arrived at the dinner, volunteered to give an address in his place. With only a few minutes' preparation, Budd delivered what was universally regarded as a very cogent and inspiring speech.

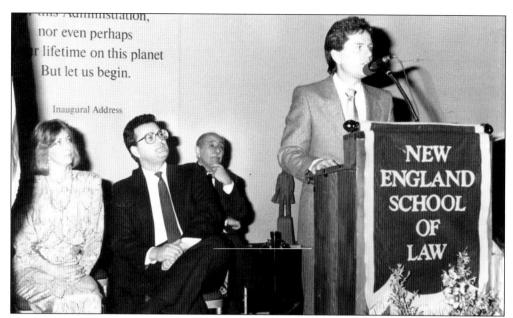

The 1988 Dean's Reception honored Andrew J. Calamare (class of 1981, second from left), then the Massachusetts Commissioner of Banks. Sitting on the left is his wife, Susan Quinn Calamare, who had been the school's director of financial aid and its registrar. She went on to become assistant dean for students and then associate dean. She received an honorary degree at the 2004 commencement. Associate Dean John F. O'Brien is speaking.

The 1988 Law Day speaker was Charles Fried, then the solicitor general of the United States. Fried also served as an associate justice of the Massachusetts Supreme Judicial Court from 1995 to 1999 before returning to his position as a professor at Harvard Law School. Here he is being introduced to Pres. Anna E. Hirsch by the student Law Day chairs.

Four

NATIONAL RECOGNITION
1988–2008

In 1988, John F. O'Brien was appointed dean of New England School of Law, only the second dean in its history to be a graduate of the school. After graduating first in the class of 1977, O'Brien had been on the board of trustees in the early 1980s and had joined the faculty in 1985. As dean, he enjoyed an unprecedented level of support from the board of trustees and Chairman James R. Lawton, who knew and trusted him.

With that support, O'Brien embarked on a program to bring the school's academic credentials up to the highest national standards and to raise the school's profile both locally and nationally. More faculty were hired, faculty publications increased, and academic centers were established. New England School of Law joined other independent law schools to form the Consortium for Innovative Legal Education. The school established a strong international law program through its Center for International Law and Policy.

To increase the number of minority students, O'Brien created the innovative Charles Hamilton Houston Enrichment Program. The school also established new scholarship programs to attract outstanding students and initiated foreign study programs. In 1994, the school purchased a second building and renovated the Stuart Street building to add to classroom, faculty, and library space. It expanded the use of computer technology, now supported by a large, centralized information technology staff. In 1998, New England School of Law was admitted to the Association of American Law Schools, a formal recognition that the law school now met the highest national standards of legal education.

Beginning in 1998, O'Brien also assumed a series of leadership positions in the ABA accreditation apparatus, ultimately serving as chair of the ABA accreditation committee and sitting on the Council of the Section on Legal Education and Admissions to the Bar.

The law school has entered the 21st century well positioned to continue the progress it made in the previous one. Its new stature was apparent in the visits of many prominent figures, including six members of the U.S. Supreme Court. The school has also launched an ambitious new scholarship program to further improve the quality of applicants; has initiated faculty programs to promote interactive teaching; and is preparing for yet another expansion of its facilities. New England School of Law and its many graduates look forward to a future that promises innovation and advancement while preserving the best traditions of its past.

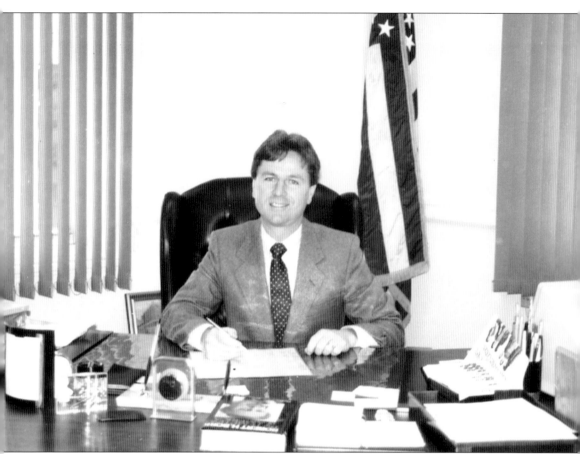

In the summer of 1988, John F. O'Brien succeeded Kenneth R. Evans as dean. O'Brien was only the second dean (after Margaret Bauer) to be a graduate of the law school. After graduating first in his law school class in 1977, O'Brien joined the office of chief counsel of the Internal Revenue Service and earned a master of laws in taxation from Boston University. As president of the New England School of Law Alumni Association, he had occupied a seat on the school's corporation and the board of trustees. In 1985, he resigned those positions and joined the faculty, becoming associate dean in 1986. O'Brien set the school's sights on continuing—and increasing—its progress toward greater recognition. He spurred the production of published faculty scholarship by creating programs of regular sabbaticals and summer research stipends. He reached out to employers who had never before hired a New England School of Law graduate, to make them aware of the school's progress. He promoted the nationwide recruitment of students and especially of minority students. He also brought notice to the school through a series of visits by Supreme Court justices.

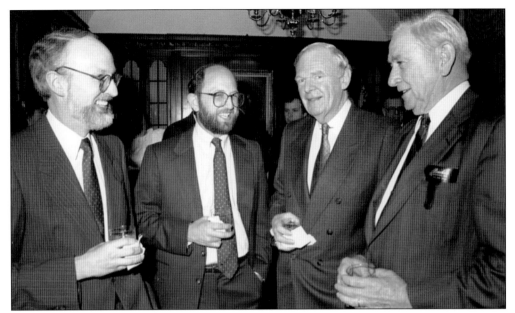

O'Brien chose Prof. Philip Hamilton, the director of clinical programs, as his associate dean. That association proved very stable and productive, lasting for 16 years until Hamilton returned to the faculty in 2004. Pictured from left to right in this 1989 photograph, Hamilton gets some pointers from trustee Cary Sucoff (class of 1977), a former member of the faculty; former dean Timothy J. Cronin; and former admissions director John J. Daley (class of 1950).

One of O'Brien's goals was to increase minority enrollment from the low level of three percent when he became dean in 1988. By 1991, minority students made up 11 percent of the entering class and by 1995, they were 16 percent.

As more minority students entered the school, the Minority Students Association became more active, both in the school and in the community. An example was the Adopt-a-School Program, which sent New England School of Law students into inner-city schools. These are photographs from mock trials conducted in the 1990s in the New England School of Law courtroom by students of an adopted grade school under the tutelage of law school students, who are sitting with them at the counsel tables. In the above photograph, the students await the judge in a courtroom packed with their peers. The photograph below is of law students who participated in the program in a later year.

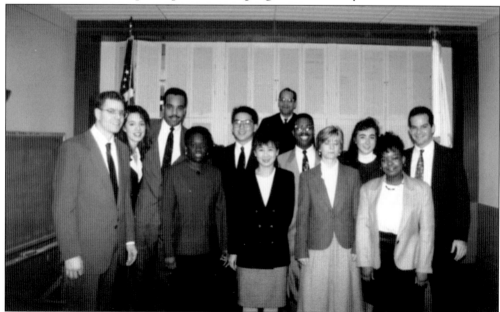

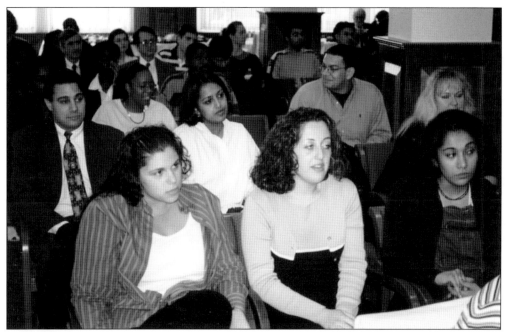

In 1989, the law school created the Charles Hamilton Houston Enrichment Program (CHHEP). The program had two purposes: to provide academic support when needed and to create a supportive community for students of color through speakers, awards, seminars, and other programs. This photograph was taken at a CHHEP awards ceremony.

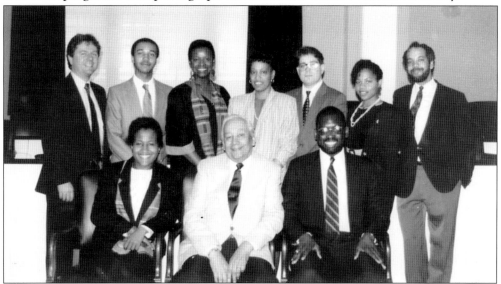

Student leaders of the CHHEP pose here with Dean John F. O'Brien and other supporters. From left to right are (first row) Karen Von Winbush (class of 1990), trustee Judge Darrell Outlaw of the Dorchester District Court (class of 1961), and Pierre Monette (class of 1991); (second row) O'Brien, Peter Wood (class of 1990), Romaine Martin (class of 1992), assistant U.S. attorney Antoinette Leoney (class of 1984), Jose Silva (class of 1991), Tasha Smith (class of 1992), and Prof. Charles Walker. Missing from the photograph is Prof. Judith Greenberg, who chaired the task force that created the CHHEP program.

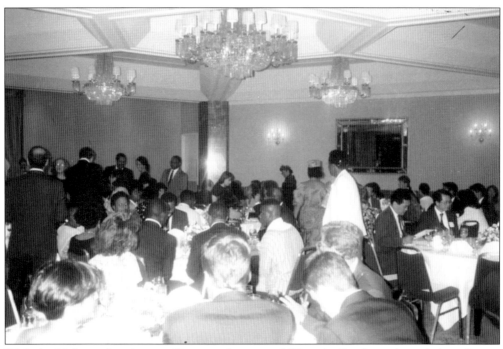

With the higher minority enrollments, the annual Minority Students Association dinner became a much larger event, as can be seen in this photograph. Minority alumni from around the country attend the dinner.

By the 1990s, the law school was attracting more than 70 percent of its full-time students from outside Massachusetts. As the number of out-of-state alumni increased, the school scheduled regular alumni events in New York, Florida, and other states. This is a photograph of a 1990 alumni gathering in Rhode Island, hosted by Rhode Island attorney general James E. O'Neill (class of 1967), in the foreground.

In 1990, the law school dedicated the Anna E. Hirsch Courtroom in honor of the 1928 graduate who had joined the board of trustees, pushed for the changes necessary for ABA approval, and became the school's president. At the dedication ceremonies, Hirsch (seated center) posed in the courtroom with members of the board of trustees.

The staff of the *New England Law Review* dedicated the 1989–1990 volume to Massachusetts chief justice Edward Hennessey, who had just retired. Pictured at a reception marking the event are, from left to right, (first row) Justice Paul Liacos of the Massachusetts Supreme Judicial Court, Michelle Thereoux (class of 1990), and Chief Justice Hennessey; (second row) Judge Arthur Sherman of the Massachusetts Trial Court, Prof. Thomas C. Fischer, Prof. George Dargo, Joseph Capezzuto (class of 1990), and Joan Legraw (class of 1989).

In September 1991, Justice Sandra Day O'Connor of the U.S. Supreme Court came to New England School of Law to deliver the Anna E. Hirsch Lecture. She responded to a personal invitation from a student, Angela Bucci, who described to her the school's history as a law school for women. O'Connor met with students and with faculty and delivered the lecture to a packed dinner audience. Above, Justice O'Connor's husband, John Jay O'Connor, is on the far right. Below, the student to the right of the podium is Bucci, who was cochair of the committee that organized the event. The other cochair was William Casey, seated to the left of the podium. Casey went on to become deputy superintendent of the Boston Police Department and is now a law school trustee and president of the alumni association. On the far left is Gov. William Weld.

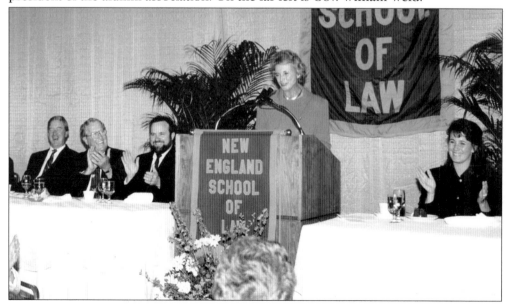

During the day, O'Connor met Pres. Anna E. Hirsch (right). In her speech that night, she lauded Hirsch as a pioneer who, by acquiring a legal education in 1928, was an inspiration to women who came after her. Like Hirsch and some other Portia Law School graduates, O'Connor faced obstacles on entering the profession and ultimately found advancement through the political process.

When the Iron Curtain came down in 1989, the ABA established a Central and Eastern European Law Initiative (CEELI) to give assistance to developing legal systems in the former Soviet bloc. In the 1990s, the law school was chosen to participate in CEELI and was paired with the law faculty of the University of Bucharest in Romania. The partnership resulted in the donation of books and computer equipment and in teaching stints in Bucharest for New England School of Law property law professor Paul Teich (at left) and commercial law professors Susan Finneran and Gary Monserud. The partnership also led to a visit to Bucharest by Dean John F. O'Brien in 1992, where he met with members of the law faculty and with the Romanian Supreme Court (below).

From 1992 to 1994, the law school expanded and refurbished its physical plant. The renovations to the Stuart Street building were completed in 1994, in time for the beginning of the school year. The improvements included a complete conversion of the fifth floor from offices to classrooms and an expansion of the library. These photographs show the fifth-floor corridor with new student lockers as well as a new large classroom. This classroom was later dedicated to Mark Charbonnier, an evening student who was killed in his last year of law school while on duty with the state police. He died in September 1994, a few days after classes began, and was awarded his degree posthumously at the 1995 commencement.

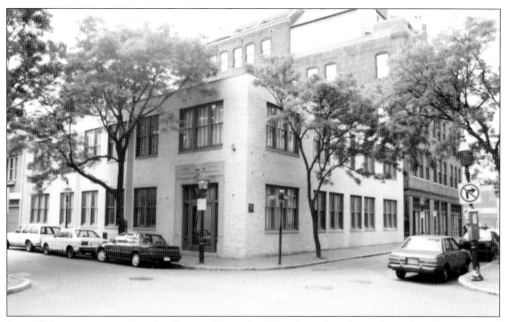

In addition to renovating the Stuart Street facility, the school purchased and renovated this building at 46 Church Street in the Bay Village neighborhood, a three-minute walk from the Stuart Street building. The administrative offices were moved to Church Street in December 1993. That left the fifth floor of the Stuart Street building free to be converted to classrooms and allowed the library to take over the entire second floor.

During the renovations, the student organizations were shifted from space to space. This is one of the places where *Due Process*, the student newspaper, was assembled. The law school has had a student newspaper or magazine since 1926, when the *Portia Punster* was established, followed by the *Portia Prattler* in 1932. The first yearbook, the *Legalite*, was issued in 1927. The yearbook was renamed *Legacy* in 1932 and still bears that name.

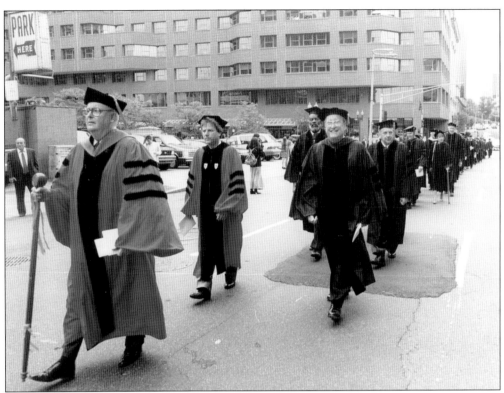

Since 1986, the law school has held its commencement exercises in the Wang Center for the Performing Arts (now the Citi Center for the Performing Arts). The graduating class, led by faculty, trustees, and honorees, has marched the two blocks to and from the Wang in full regalia, preceded by drums and bagpipes. Here the marshal, Prof. Robert E. O'Toole, leads the procession in the 1990s. When the students enter the auditorium, the sound of the bagpipes is replaced by the music of a brass ensemble as the students file into their seats. In spite of the size of the graduating class, typically around 300, each student comes up to the stage to receive the diploma from the chairman and congratulations from the dean.

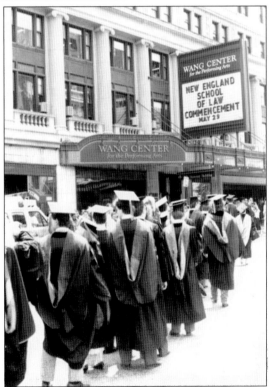

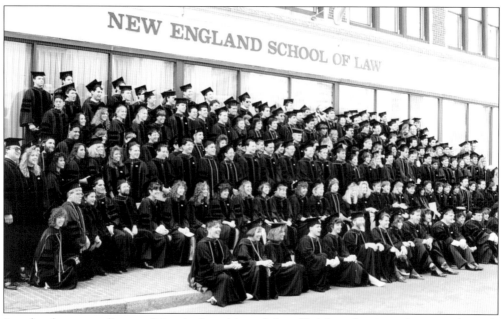

Another long-standing tradition is the taking of the official graduation photograph. Each division (day and evening) of the graduating class stands on risers that are specially erected in front of the law school. Traffic on Stuart Street is temporarily stopped while the photographer snaps the picture from across the street. In this photograph, the day division of the class of 1991 gets ready to "say cheese."

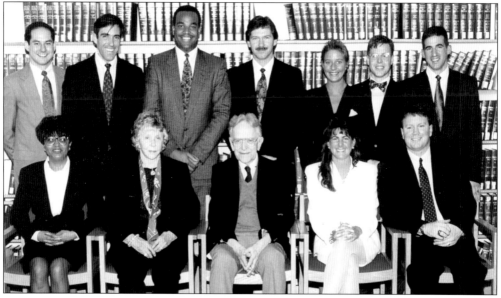

In 1993, Justice Harry Blackmun of the U.S. Supreme Court was the Law Day speaker. Blackmun accepted the invitation to demonstrate his respect for the memory of Prof. Mary Joe Frug, who had been murdered two years before. His Law Day speech attracted national attention when, in alluding to the possible retirement of Justice Byron White, he suggested that he also might retire soon. In the afternoon, he and his wife, Dorothy, met with student leaders, pictured here.

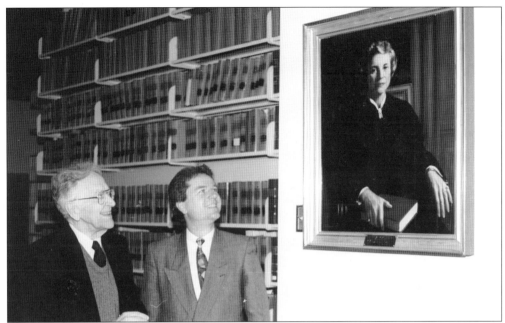

Beginning with the visit of Justice Sandra Day O'Connor, the law school has commissioned an oil portrait of any Supreme Court justice who visits the law school. The original portrait hangs in the school library and the dean delivers a photographic copy to the justice in Washington. Above, Dean John F. O'Brien and Blackmun admire the O'Connor portrait in the New England School of Law library. The photograph below shows the Blackmun portrait, unveiled at the Law Day dinner after Blackmun's speech. The artist who has painted all of the portraits is Georgianna Nyman Aronson, shown here (second from right) with Blackmun and the Law Day cochairs.

One of the attendees at Justice Harry Blackmun's Law Day speech was Judge Stephen G. Breyer, then the chief judge of the U.S. Court of Appeals for the First Circuit. In 1994, Breyer was appointed to the Supreme Court, having been nominated by Pres. Bill Clinton to fill the vacancy created by Blackmun's retirement. Here, from left to right, Blackmun greets Breyer and Justice Neil L. Lynch of the Massachusetts Supreme Judicial Court.

In 1993, Mary Danehy retired after more than 20 years with the law school. She was director of admissions from 1982 to 1993, managing the admissions process during years of increasing enrollment. In this photograph, she is being honored at the 1993 commencement.

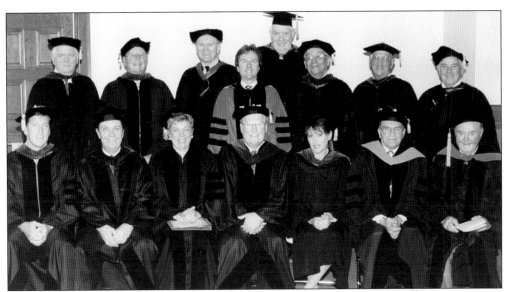

This is a photograph of members of the board of trustees with Dean John F. O'Brien in the mid-1990s. Pictured from left to right are (first row) Richard Lawton (class of 1982), Pres. Martin C. Foster (class of 1980), Judge Susan Crawford (class of 1977), Chairman James R. Lawton (class of 1953), Judith Wayne (class of 1976), Harold Udell (Sc.D. class of 1960, Calvin Coolidge College), and John F. X. Davoren (class of 1963); (second row) George Carney, Joseph Pulgini (class of 1969), Robert Quinn, Dean O'Brien, Bradbury Gilbert, Judge Darrell Outlaw (class of 1961), Joseph Ayoub (class of 1940), and Joseph Lorusso.

Michael Scharf joined the New England School of Law faculty in 1993. A former U.S. State Department attorney, Scharf established the law school's Center for International Law and Policy in 1996. He also expanded the school's international curriculum and established a summer abroad program with the Irish Centre for Human Rights at the National University of Ireland, Galway. He is shown here with Geraldine Ferraro, the former congresswoman, vice presidential candidate, and diplomat, who was the 1994 Law Day speaker.

In 1996, the New England School of Law Center for International Law and Policy initiated the International War Crimes Project, through which students provide legal research and analysis to the office of the prosecutor of the International Criminal Tribunals for the former Yugoslavia and Rwanda. Since its inception, the project has provided more than 100 legal memoranda to the war crimes prosecutor. In this photograph, Prof. Michael Scharf (left) confers with students enrolled in the project in 1997.

The New England School of Law faculty has been crucial in the school's progress. Pictured here are Prof. Barbara Plumeri (class of 1982) and Prof. Curtis Nyquist at the 2002 Dean's Reception honoring Plumeri. Plumeri and Nyquist have each been at the school for more than two decades, as have at least 16 other faculty members. This stable, committed faculty has provided continuity in instruction, cocurricular opportunities for students, and administrative work, as well as an impressive body of scholarship.

The law school has always prided itself on its sense of community. In reality, it is a community that contains several other communities: students, faculty, administrative staff, librarians, and trustees. Events like the Law Day observance and the Minority Students Association dinner promote a sense of common purpose and shared experience. Smaller-scale events and gatherings provide a network of support and encourage a feeling of camaraderie. These photographs show two such events in the late 1990s. Above is the annual employee picnic, which has been held in parks, at the dean's house, and onboard ships, as was the case that year. Below, students gather at a golf outing, one of the many events sponsored by the Student Bar Association.

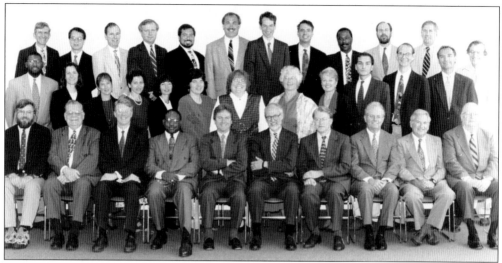

This is the full-time faculty for the 1996–1997 school year. In 1983, there were 27 full-time faculty members. In 1990, there were 32. By 1996, that number had increased to 39, and 34 are pictured here. In addition to being larger, the faculty had become more diverse and more focused on scholarly publications during the O'Brien deanship. These changes reflected the school's determination to achieve membership in the Association of American Law Schools.

Kathleen M. O'Toole (class of 1982) was recognized at the 1996 Dean's Reception and is shown here receiving a certificate from Dean John O'Brien. O'Toole, who had attended law school while working as a Boston police officer, was the Massachusetts secretary of public safety from 1994 to 1998. In February 2004 she was appointed Boston police commissioner, the first woman to serve in that position. In July 2006 she became chief inspector of the Garda Inspectorate, the auditing body of Ireland's national police force.

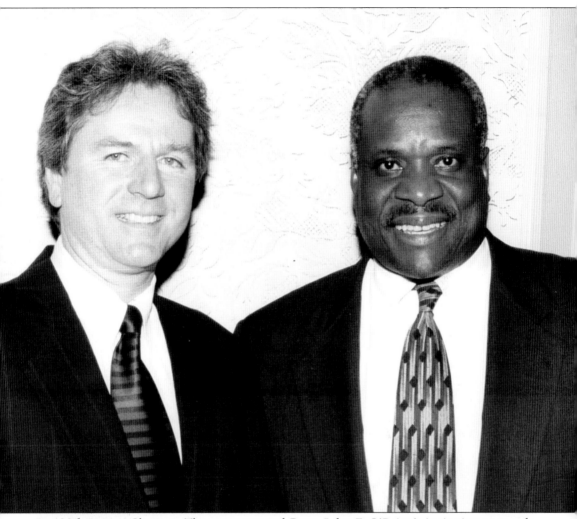

In 1996, Justice Clarence Thomas accepted Dean John F. O'Brien's invitation to speak at the law school. Thomas had gone through a contentious confirmation process when he was appointed to the court in 1991. The 1996 dinner, which was attended by nearly all the judges on the local federal bench, was widely seen as a welcome opportunity for reconciliation and moving on.

Adding to the spirit of reconciliation was the surprise attendance of Justice Stephen Breyer, who wanted to be present for Justice Clarence Thomas's speech. Below, Breyer is flanked on the left by Justice Neil L. Lynch of the Massachusetts Supreme Judicial Court and on the right by federal district judge Robert E. Keeton and Chairman James R. Lawton of the New England School of Law Board of Trustees.

Here O'Brien and Chief Judge Joseph L. Tauro of the U.S. District Court for the District of Massachusetts applaud Thomas's address.

Richard Huber, dean of Boston College Law School from 1970 to 1985, joined the New England School of Law faculty as a distinguished visitor for several years in the 1990s. Besides being a fine teacher and a very helpful colleague, he was a valued counselor to both the administration and the faculty in the law school's application to join the Association of American Law Schools. Here he is (second from left) with, from left to right, Lawton, O'Brien, and trustee John Simpson.

In the 1990s, the law school continued to attract nationally prominent Law Day speakers. In keeping with the school's tradition of promoting women in the law, the scheduled Law Day speaker in 1995 was Janet Reno, the attorney general of the United States, the first woman to hold that office. The attorney general was called away at the last minute, but solicitor general Drew Days took her place and was a gracious guest and gave a fine speech. Here he is being introduced by Chairman James R. Lawton. Reno promised to appear at the next year's Law Day, and true to her word, she was the 1996 speaker.

In 1997, New England School of Law joined four other independent law schools to form the Consortium for Innovative Legal Education (CILE). That has resulted in various forms of cooperation, especially in developing study abroad, distance learning, and other educational programs and in shared information on financial, administrative, and other systems. Three of the five original CILE deans can be seen in this photograph. From left to right are Dean Frank T. Read of South Texas College of Law, Dean Harry J. Haynesworth of William Mitchell College of Law, and Dean Lizabeth A. Moody of Stetson College of Law. Also present were Dean Steven R. Smith of California Western School of Law and Dean John F. O'Brien of New England School of Law. The second photograph is of students and faculty in New England School of Law's Galway summer program, which is offered through CILE.

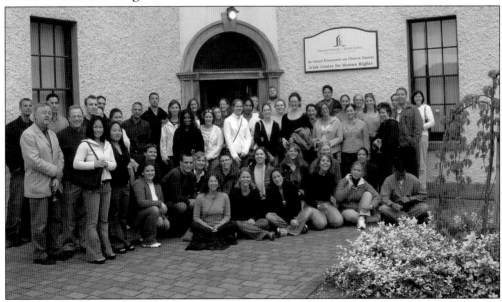

In 1998, New England School of Law was admitted into the Association of American Law Schools (AALS), in recognition of its achievement of the highest national standards of legal education. After the induction ceremony at the AALS Annual Meeting in San Francisco, the law school hosted a reception, where these two photographs were taken. Above, Dean John Sexton (second from right) of New York University School of Law, then the president of the AALS, congratulates, from left to right, Dean John F. O'Brien, Associate Dean Philip Hamilton, and Chairman James R. Lawton. Below are a few of the many New England School of Law faculty who attended. From left to right are Anne Acton, then the assistant director of the library; Prof. Russ VerSteeg; Kenneth Klein, a former faculty member; and Prof. Gary Monserud.

To assist the school in the AALS application process, Prof. John A. Bauman of the University of California at Los Angeles School of Law was retained as a consultant. In appreciation of his patience, his sensitivity, and his wise counsel, the school conferred an honorary degree on him at the 1998 commencement. Here trustee Robert Quinn presents Bauman.

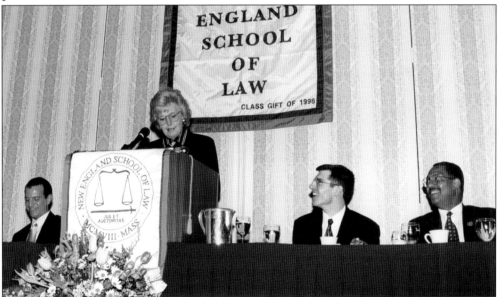

The 1999 Law Day speaker was Chief Justice Margaret H. Marshall of the Massachusetts Supreme Judicial Court. She was the first woman chief justice since the 1692 establishment of the Massachusetts Supreme Judicial Court, the oldest appellate court in the western hemisphere. Marshall is flanked by the Law Day cochairs and on the far right by her colleague Justice Roderick Ireland, a longtime supporter of the school and of its Charles Hamilton Houston Enrichment Program.

In 1999, Judge James R. Lawton marked 30 years as chairman of the New England School of Law board of trustees. At an event to celebrate the occasion, Dean John F. O'Brien relates a humorous anecdote about the chairman. The warm, personal relationship between the two men was an important factor in the law school's progress during the O'Brien deanship.

Among the activities that bring students and faculty together is the annual coed student versus faculty softball game. Students pay to play and the proceeds support summer public-interest internships. In this photograph from the 2001 game, from left to right, professors Gary Monserud, Philip Hamilton, and Charles Sorenson (with the tie) check out the students' play in the field, while Prof. Joelle Moreno mugs for the camera.

In 2002, the law school purchased an adjoining building on Warrenton Street, shown here in an artist's rendering. The law school's Stuart Street building is on the right. The building is occupied until 2011, but after that date, the school anticipates moving into larger quarters.

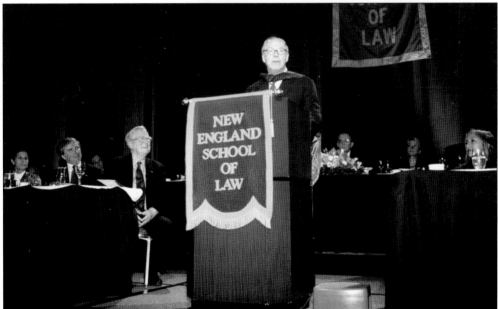

On April 18, 2003, the Law Day speech was given by Hans Blix, who was the head of the United Nations Monitoring, Verification, and Inspection Commission in Iraq. Blix's team was pulled out of Iraq only a month before the dinner. Until shortly before the dinner, the Law Day committee was not sure that Blix would be able to attend. Blix had accepted the invitation contingent on his inspection team no longer being in Iraq.

In 2004, for the first time in memory, it rained on the graduation procession from the law school to the Wang Center. The facilities and security staff handed out umbrellas to cover all the participants, including the entire graduating class. Here members of the faculty share umbrellas.

The 2004 commencement speaker was Associate Justice Robert Cordy of the Massachusetts Supreme Judicial Court. Here Cordy (second from left) waits with Chairman James R. Lawton and other dignitaries for the ceremony to begin. Cordy is a longtime supporter of the school and is also a popular member of the adjunct faculty, teaching a course on advanced criminal procedure.

At the 2004 commencement exercises, the law school conferred an honorary degree on Susan Quinn Calamare in recognition of her many contributions to the school. Calamare began working for the law school in the 1970s and served at different times as financial aid director, admissions director, registrar, alumni director, and assistant dean. She was an indispensable facilitator of the many changes that enabled the law school to achieve and then exceed national standards of administration. In 2007, she was made associate dean. Pictured from left to right are Anna Chopek (class of 1935), who also received an honorary degree; Chairman Lawton; and Pres. Martin C. Foster, presenting Calamare for the degree.

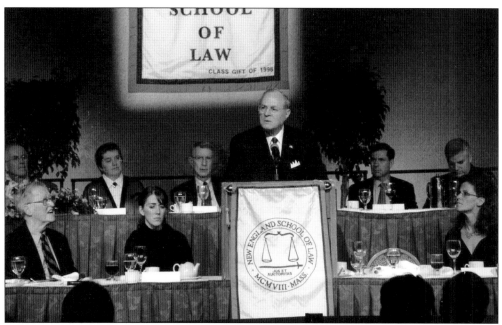

U.S. Supreme Court Justice Anthony Kennedy was the speaker at the 2005 Law Day observance. At the time of his visit, the Supreme Court had just announced its decision in *Roper v. Simmons*, holding that it is unconstitutional to impose capital punishment for crimes committed while under the age of 18. Kennedy had written the majority opinion in that case. The photograph above shows Kennedy speaking before a head table of judges from the Massachusetts and federal benches. In the photograph below, Dean John F. O'Brien and artist Georgianna Nyman Aronson present Kennedy with his portrait. Kennedy's wife, Mary, is to the right of her husband.

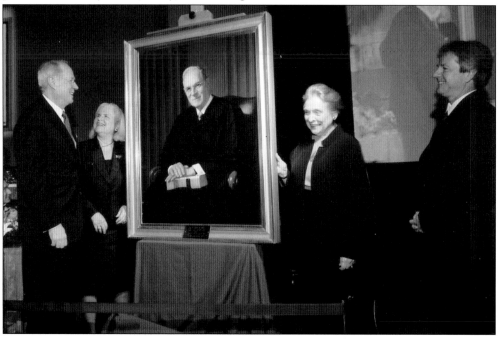

During his visit, Kennedy taught two classes. He led a discussion with evening division students in a class on the Law and Ethics of Lawyering, a required, upper-level course, and he taught a class in Constitutional Law, a first-year course, in the day division. This is a photograph from the Constitutional Law class.

Justice Antonin Scalia was the 2006 Law Day speaker. Like Kennedy, Scalia requested the opportunity to teach during his visit. Here he teaches a Constitutional Law class to day division students. He also led a lecture and discussion on constitutional law for evening division students and hosted a question and answer session with students in the afternoon before the Law Day dinner.

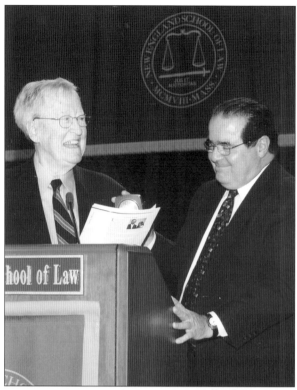

A former law school faculty member, Justice Antonin Scalia spent the afternoon before the dinner with faculty and students, and he proved an engaged and gracious visitor. At the dinner, he was introduced by Chairman James R. Lawton. When the podium light failed, Lawton had some difficulty seeing his notes. Scalia obliged by holding a flashlight on the notes, a spontaneous gesture that was warmly received by the audience.

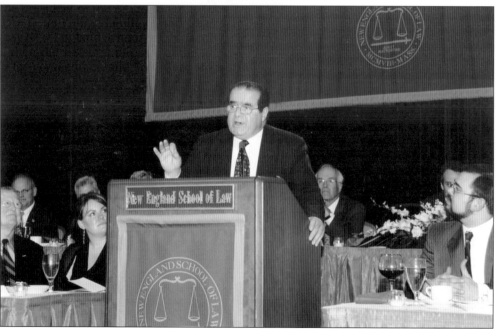

Scalia was the sixth Supreme Court justice to visit the law school, the fifth during John F. O'Brien's years as dean. The justice and the dean, both from New York City, got along so well that Scalia agreed to teach a course in the school's summer program in international and comparative human rights law, in Galway, Ireland, during the summer of 2008.

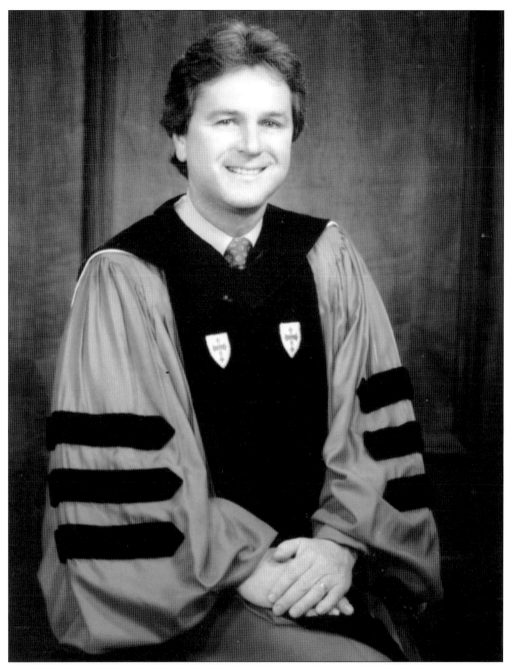

From 2002 to 2004, O'Brien was chair of the accreditation committee of the ABA's Section on Legal Education and Admissions to the Bar, the committee that oversees the process of ongoing inspection and approval of law schools. He was appointed to that committee in 1998. His appointment, besides being a tribute to him personally, was also a recognition by the national accreditation authorities of the solid educational and administrative footing New England School of Law had built up during his deanship. When his term on the accreditation committee expired in 2004, O'Brien was named to the council of the ABA's Section on Legal Education and Admissions to the Bar.

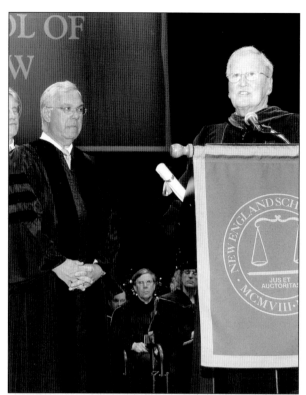

At the 2006 commencement exercises, Boston mayor Thomas Menino received an honorary degree, here being presented by Chairman James R. Lawton. This was to be the chairman's last commencement.

The 2006 commencement speaker was John L. Murray (third from left), the chief justice of Ireland. Shown here, from left to right, are Dean John F. O'Brien, Menino, and trustee Joseph J. Pulgini. Trustee John R. Simpson and Lawton (seated) are to the right.

In this photograph, students don their robes for the 2007 commencement exercises. The robing takes place at the Stuart Street building, where the students line up in alphabetical order and join the procession of trustees and faculty as it follows a team of bagpipes and drums to the Citi Center, two blocks away.

In 2007, Darrell L. Outlaw became the first African American president of the law school. In this 2007 photograph, he appears with several members of the board of trustees. From left to right, they are (first row) Judge Peter L. Brown (class of 1987), Cary W. Sucoff (class of 1977), Judge Darrell L. Outlaw (class of 1961), wife Mattie Outlaw, and Natashia M. Tidwell (class of 2003); (second row) Judith A. Wayne (class of 1976), Albert A. Balboni (class of 1983), Diana L. Wheeler (class of 1990), and Wheeler's husband Peter Mann.

At each graduation, the program lists the current graduates who are the children of alumni. In this photograph from the 2007 commencement, Inesse Semeah (class of 2007, right), poses with her mother, Romaine Martin Semeah (class of 1992), Dean John F. O'Brien, and Associate Dean Judith Greenberg. In the early 1990s, Romaine Martin was one of the students who, working with Greenberg and O'Brien, founded the Charles Hamilton Houston Enrichment Program, a program that continues to provide support and community to students of color.

The law school's security staff continues to be an important contributor to the school's welcoming atmosphere. From providing a friendly face at the lobby security desk to accompanying students to the subway after a late class, the security staff has always taken its role as facilitator for students and visitors seriously. Two longtime members of that staff are Miguel Alvarado (right), assistant director of facilities and security, and Jose Quiles.

This is the full-time faculty in 2007. From left to right are (first row) Ronald Chester, Eileen Herlihy, Judi Greenberg, John O'Brien, Paul Teich, Davalene Cooper, Russ VerSteeg, and George Dargo; (second row) Monica Teixeira de Sousa, Elizabeth Spahn, Barbara Oro, Anne Acton, Ilene Klein, Sonya Garza, Caryn Mitchell-Munevar, and Barbara Plumeri; (third row) Susan Finneran, Victor Hansen, Stanley Cox, Tawia Ansah, Richard Child, Mark Bobrowski, Dina Haynes, Peter Manus, Eric Lustig, Allison Dussias, and Curtis Nyquist; (fourth row) David Siegel, Russell Engler, Colin Smith, Louis Schulze, Philip Hamilton, Gary Monserud, Kent Schenkel, Charles Sorenson, and Daniel Ticcioni.

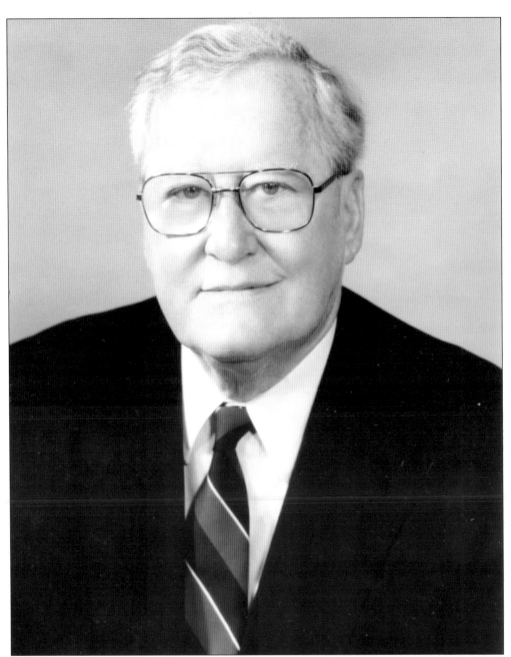

On March 19, 2007, after a brief illness, Judge James R. Lawton died. Lawton, a 1953 graduate, had joined the board of trustees in 1966. From the outset, he was a strong supporter of the changes that were necessary to achieve national accreditation. He led the effort to amend the charter in 1969, to enlarge the governing board, and to give a more active governing role to the alumni, the constituency with the largest stake in the reputation of the school. He became chairman of the board of trustees in 1969. During the 38 years of his chairmanship, he had supported the law school through the most significant changes in its history, changes that transformed it from the small, local school that he had attended to a large, respected law school with a national reach.

Lawton was succeeded as chairman by Martin C. Foster (class of 1980). Foster, a prominent medical malpractice defense lawyer, had been a member of the board of trustees since 1980 and president of the corporation since 1997. On his right in this photograph is longtime trustee and former Massachusetts attorney general Robert H. Quinn. With Foster as chairman and John O'Brien as dean, the law school's governance passed to a younger generation.

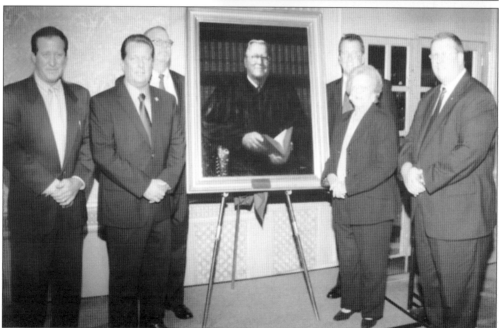

In memory of Judge Lawton, the school commissioned a portrait by Georgianna Nyman Aronson, the artist who painted the portraits of the visiting Supreme Court justices. Pictured from left to right at the unveiling of the portrait are his family, Judge Mark E. Lawton (class of 1974), Paul M. Lawton (class of 1989), Thomas D. Lawton (class of 1979), Richard J. Lawton (class of 1982), Jeanne Lawton, and Robert Lawton.

125

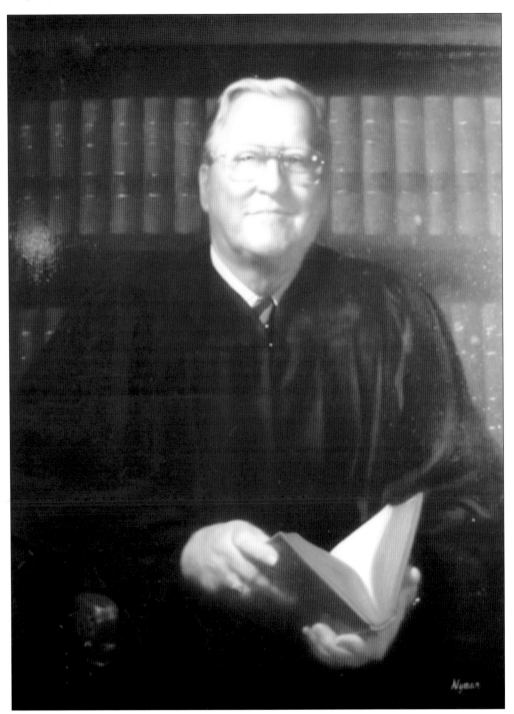

This is the portrait of Judge James R. Lawton painted by Georgianna Nyman Aronson. In the words of his successor, Chairman Martin C. Foster, the portrait shows Lawton's "love of people, politics and the law" that "inexorably led him to a life of service." New England School of Law was fortunate to be a beneficiary of that service.

The most important asset of New England School of Law is its graduates. It is through them that the school's value as an educational institution is realized, and it is through their good work that the school's reputation grows. New England School of Law looks forward to a future that promises innovation and advancement while preserving the best traditions of its past. These are members of the graduating class of 2007.

ACROSS AMERICA, PEOPLE ARE DISCOVERING SOMETHING WONDERFUL. *THEIR HERITAGE.*

Arcadia Publishing is the leading local history publisher in the United States. With more than 3,000 titles in print and hundreds of new titles released every year, Arcadia has extensive specialized experience chronicling the history of communities and celebrating America's hidden stories, bringing to life the people, places, and events from the past. To discover the history of other communities across the nation, please visit:

www.arcadiapublishing.com

Customized search tools allow you to find regional history books about the town where you grew up, the cities where your friends and family live, the town where your parents met, or even that retirement spot you've been dreaming about.